KU-305-058

0202318838

778.324 PAP

Photography Film
and Communication Studies Library
The Polytechnic of Central London
309 Regent Street W1R 8AL
OMMUNICATION LIBRARY, P.C.L.,
18-22, RIDING HOUSE ST., W1P 7PD

Photomacrography:
Art and Techniques

COMMUNICATION LIBRARY, P.C.L.,
18-22, RIDING HOUSE ST., W1P 7PD

Jean Papert

AMPHOTO
American Photographic Book Publishing Company, Inc.
New York, N.Y. 10010

ACC.
NO. 7-4721

CLASS 778.324

ACKNOWLEDGMENTS

Many thanks to Hollis Todd, James McMillion, Judith Steinhauser, Owen Butler, David Robertson, Tom Wilson, and Gary Metz of the faculty of Rochester Institute of Technology; to Betsy Bernet for the use of her extension tubes; to the Amphoto staff; to W. Eugene Smith; to Tony and Susan Papert; to Reuben and Louise Papert; and to John Griesser.

Copyright © 1971 by Jean Papert

Published in New York by American Photographic Book Publishing Company, Inc. Manufactured in the United States of America. All rights reserved. No part of this book may be reproduced in any manner without written consent of the publisher.

Library of Congress Catalog No. 78-134240

ISBN 0-8174-0536-4

Preface

When we are children, we all want desperately to grow up. But when we do, something important goes out of our lives. No longer do we greet each day with a sense of expectation concerning all the new and wonderful things we'll see, hear, touch, smell, and taste. When we are in our late teens, we get the depressed feeling that we already know it all, that life has lost all its surprises. This is a very sad feeling indeed.

Now and then, someone comes along to prove us wrong: life *has not* lost its surprises. Such a person is Miss Jean Papert, with her wise little book on photomacrography. She makes it indelibly clear that fresh and delightful surprises are as close to you as your own fingertips. All you need is a means for magnifying your ordinary vision, which photomacrography does admirably. Magnify your own fingertips and a whole new world will open itself to you. When you run out of fingers, think of all the other things you can magnify and delight in.

Though photomacrography is not new, Jean Papert's approach to it is. Older hands have insisted on seeing it as a tool for the biologist who wants to see things better so that he can take them apart and learn their functions.

Jean Papert says, "You don't have to limit yourself this way. Why not approach photomacrography as an esthetic experience? Let it open up new visual worlds for you and bring the sense of wonder back into your life."

This is a marvelous approach, in my opinion. I'm pleased that Jean, for all her youth, has found a way of describing it in terms everyone can understand.

She has also sensed that the people who will take most delightedly to her idea may not be especially interested in photographic technology. Indeed, they may find it frightening. For such folk, she has spelled out the methods with admirable simplicity. She has shown that simple, relatively inexpensive equipment will suffice and that one doesn't have to be a scientific genius to learn to use it well.

I am proud of Jean Papert for what she has brought to us. Read her fine book. Then pick up your camera and sally forth in search of exciting new worlds.

RALPH HATTERSLEY

Contents

Foreword

Macro photographs?

I usually have to stop and think what they are (a micro-macro confusion) and shuffle embarrassedly as I try to straighten my technical understandings.

This is a "how to do it" book. So perhaps I shall finally get my definitions straight. It can also be a trip of creative serendipity through which the mind let free can exult among images of "things that are that aren't."

I knew nothing of this book to be the night I saw Jean Papert's photographs. I was shown her photographs among many others, and they hit me the way good photographs should. They kicked me in the thinking. They made immediate demands upon my emotions. And on the most appreciated level they snapped my imagination loose from its habits of perception. And that special ability I trust is preserved in the editing and the layout of this book.

Yes, they hit me the way good photographs should — in spite of a bad situation. I was exhausted before I began to look at them. I was in physical pain. My ability to see a photograph quite diminished, numbed, by the sheer weight of the general mediocrity thrust upon me during marathon hours as a "guest" lecturer.

My vision straightened even as it flipped. It cleared exhaustion in adrenalin leaps of psychic excitement. I liked these photographs. These photographs by so quietly unpretentious a young woman. Photographs causing me excitement in a room hardly made less bare by walls of deadcrafted photographs. Photograph after photograph of Jean's choreographed my vision. I criss-crossed and whirlpooled the images I was seeing and they kept on working and I know I began to smile in

appreciation, and I thought who needs a drug high when they have images like these.

For me, these were conjure images that could change meaning and even image as I stared at them. Although I am a journalist basically trying to grasp a pulsebeat of reality in mood and fact, such photographs as Jean's are health food to my imagination. And delicious. And I truly do not care whether the source material was cabbage or moonrock — my appreciation was for the mysterious presence they now offered.

If the publisher and even Jean perhaps are looking glum that I have stressed the free blown rather than the practical aspects of her images in illustration of how to do macro photographs, I will appreciate their concern. There are those who may have some definite purpose in mind that is not served by mind expansion. But I believe these individuals, quite beyond becoming technically well groomed, have also the rare chance of seeing rare artistry in an uncommon revelation of the subject matter.

I have a friend who, after seeing the photographs, could not understand this unusual burst of enthusiasm on my part. He could see very little in the photographs. He felt they were as "dull as dishwater." I wish I knew how to get him to peel back narrowness of traditional recognitions dulling his inner seeing. But it takes self discipline to uncondition the mind, to surrender to freedom, to validate the journey into the domain of "things that are that aren't."

And I feel confident that Jean Papert would approach dishwater in a way that would make it, photographically, anything but dull.

W. Eugene Smith

Introductory Note

Beneath our eyes lies a world that has been little explored. Not that amazing microcosmos which only the microscope can reveal, but a world which, though visible to the naked eye, can best be seen by magnification through a lens. Jean Papert's lens is a camera fitted with extension bellows to permit extreme close-ups. Common objects — the pit of an apple, the whorls of a fingertip, the weblike structure of a drop of viscous liquid, the veins of a leaf, isolated on the film and enlarged with precision on paper, delight us by intensifying our vision and often satisfy our esthetic sense by their challenging form. Ferdinand Léger, the French painter, wrote in 1925: "Enormous enlargement of an object or a fragment gives it a personality it never had before, and in this way it can become a vehicle of entirely new lyric and plastic power." Although he was writing about cinema, he also defines the esthetic potentials of photomacrography, so ably demonstrated by Jean Papert in her photographs and expository text.

BEAUMONT NEWHALL

Introduction

Between photography, in which the image on the negative is smaller than the subject, and photomicrography, in which the image on the negative is enlarged with a microscope, lies photomacrography.

Photomacrography is the process of taking life-size or larger-than-life-size photographs. The negative, not the print, must depict the magnified image. For example, if you were to take a picture of a letter in this book, you would have a photomacrograph if the size of the letter on the negative was to be equal to or larger than the original letter.

If you are entering this field for the first time, and especially if you are new to the art and techniques of photography, there are two primary goals to be kept in mind. One is to become confident and proficient with the equipment and methods involved. The other is to take pictures of whatever you fancy, to "do your own thing"; your results will be much more satisfying to you if they are the product of your own thought processes. The work of other photographers can be a source of inspiration, even if you dislike their work.

This book was written on the assumption that the reader knows something about the basic materials — camera, film, and light — has a camera suitable for photomacrography, and can afford to spend some money on accessories. All you need to know to start taking macro pictures is presented in the next chapter, "Tools and Techniques." The other chapters are gravy for you to expand on, complete, or change.

A great deal of pleasure can be derived from photomacrography because it is an investigation into an unusual area of perception. I take pictures of anything

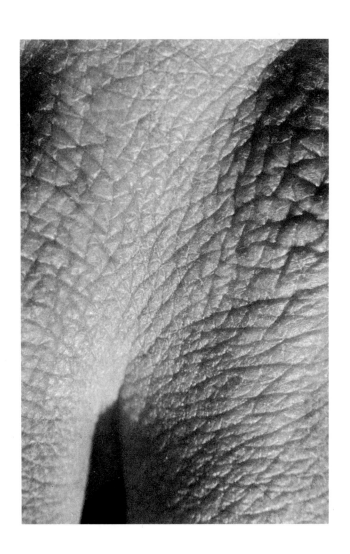

I consider photogenically feasible, making my photographs the product of observation, time, and whim. After I had been taking macro pictures for a while, I realized that I had begun to look at everything twice. The first time I would observe the object normally; during the second reflection, however, my brain quietly murmured, "How would it look enlarged?" To the embarrassment of my friends and to the wonder of bystanders, I would often scrutinize my salad or press my nose close to parts of a bicycle or play with mixtures of paint. I found, and you will soon find, that in a picture of a small part of a large object, or of a small object enlarged, the object generally loses its identity. No matter how common the object may have been originally, it is now something new. Photomacrographers can smile coyly to themselves when someone looks at one of their photographs and innocently asks what it is, expecting to hear some long, incomprehensible scientific name. Quite casually, with an of-course-you-know-what-it-is air, we can tell the questioner that it is some common object like a tomato or walnut or chipped glass. But this is just one small example of the rewards meticulous examination, awareness, and sensitivity bring to photomacrographers.

If you do your own developing and printing of black-and-white film, you will save quite a bit of money and get better results by controlling every stage of your efforts. If your film is commercially processed, be sure

to do what every photographer should do anyway: crop the picture in the camera. To crop a picture is to include everything you want to include and to exclude the rest. The best time to perform this process of selection is before the picture is taken; that is, to move the subject and/or the camera around, changing the magnification and angle of view, to find the most pleasing composition. Cropping can be done less successfully by printing only part of the picture or by cutting up a print of the whole image. If you find that you are repeatedly cropping negatives or prints, you are probably not looking closely at the subject before you press the shutter release; it almost certainly means that you are losing detail and quality by using only a segment of the negative instead of the whole negative.

As in most other things, what you get out of photomacrography will depend largely on what you put into it. It cannot be stressed enough that if you avoid learning the techniques involved (use of camera, macro accessories, lighting, exposure), photomacrography will be a lesson in frustration. If you consider the subjects carefully and exercise patience in manipulating the lights and choosing the composition, the doors of photomacrography will truly be opened.

A very common subject, the human hand, is reexamined on pages 2, 5, 6, and 7. These four photomacrographs were life-size on the 35mm negative. They were enlarged through printing and now appear much larger than life-size.

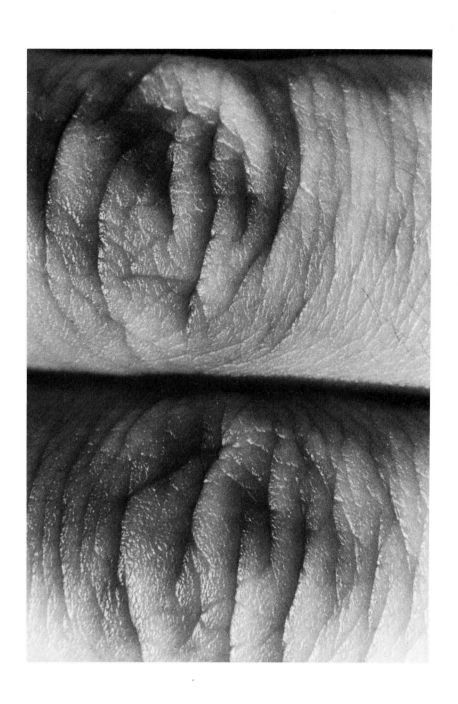

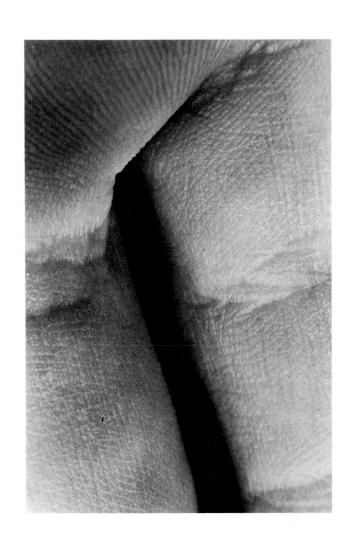

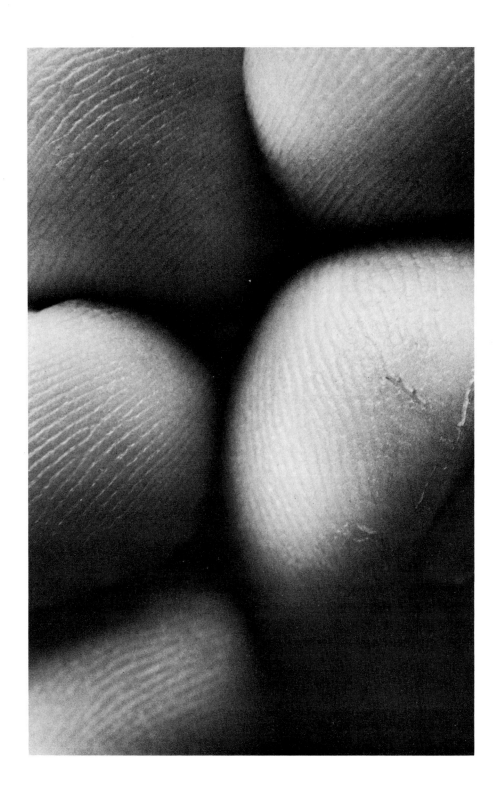

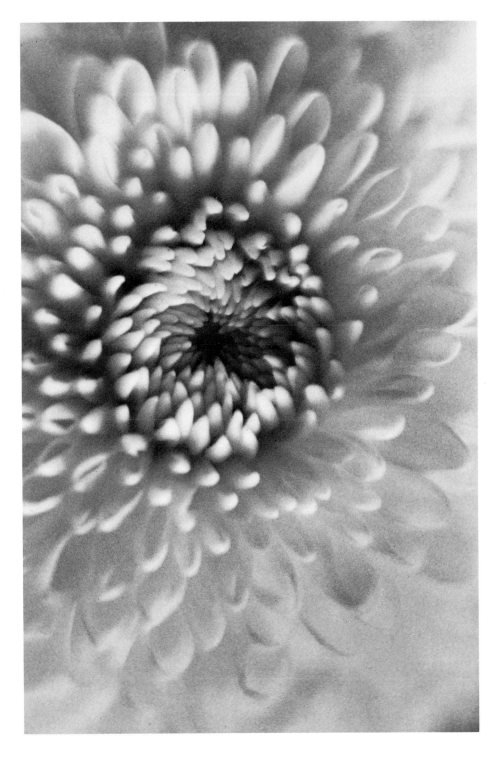

This chrysanthemum was photographed by holding a magnifying glass in front of the lens of a rangefinder camera.

1

Tools and Techniques

The process of photomacrography should not be difficult to learn. There are several choices of equipment and several ways to use the equipment, each with its own advantages and disadvantages. It would probably be best first to master one set of tools and one technique and then to go on to others. In this way you can be free to concentrate on the subject at hand without distractions from an array of unfamiliar equipment.

This chapter is divided into 11 sections: basic principles, camera, standard lenses, close-up lenses, extension tubes, bellows, lighting, exposure, depth of field, film, and other accessories. Each section was meant to be a guide and was not written with the intention of giving all the answers. The lighting and design of every photomacrographic subject makes unique demands on the ingenuity and creativity of the photographer.

It should be understood that each section in "Tools and Techniques" is dependent on the others: the choice of lenses, magnification, and exposure are interrelated. To understand the relations it may be helpful to reread parts of the chapter that are unfamiliar to you. However, the sooner you get involved in the actual work, the faster you will learn. Doing it is easier than reading about it, and it is not necessary to know all the points in this chapter before you begin.

SOME BASIC PRINCIPLES

Three principles underlie photomacrography, regardless of which camera, which lens, and which accessories are used:

1. The size of the image on the negative becomes larger as the distance between the lens and the film

is increased and the distance between the object and the lens is decreased.

2. When the distance between the lens and the film is equal to the distance between the object and the lens, the image on the negative is the same size as the real object, or the image is *life-size*. The relation of the image size to the object size, known as the *image ratio*, is then 1:1. To obtain a life-size image you usually need certain accessories, which will be described in this chapter.

3. When the distance between the lens and the film is greater than the distance between the object and the lens, the size of the image on the negative will be greater than the size of the real object. In this situation the image is magnified. The image ratio is then expressed so that the first numeral is greater than the second one, such as 1.5:1, 2:1, 3:1, and so on.

THE CAMERA

The camera should be one with which the photographer can view the subject through the taking lens, allowing him to see the image as it would appear on the film. For most purposes this eliminates rangefinder,* box, and twin-lens reflex cameras. It includes single-lens reflex cameras and view cameras. Do not despair if you have a type of camera that has just been excluded. Under the heading "Close-up Lenses" there is a description of how to use these cameras to get closer to the subject and to compensate for parallax viewing error.

View Camera

The lens of a view camera directs the image onto a diffusing glass, parallel to and directly behind the lens. The photographer can then view, compose, and focus on the subject. For picture-taking, a film back is inserted in place of the glass. These cameras are usually made for large negatives, for example, 4″ × 5″ or 8″ × 10″. They take photomacrographs when the bellows are extended or when a very short focal length lens is used.

*The Leica, although normally a rangefinder camera, can be adapted for macro equipment with a Visoflex attachment.

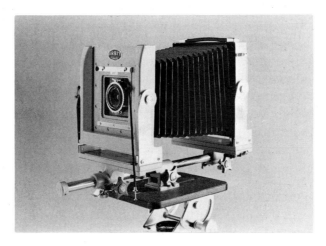

4" × 5" view camera mounted on a studio tripod.

Since the negative size for view cameras is generally larger than that for single-lens reflex cameras, the view camera print has the advantages of finer detail, greater clarity, and less grain than prints from smaller size negatives.

In photomacrography focusing is very critical, and another advantage of most view cameras over single-lens reflex cameras is that the back of the view camera can be moved to focus critically while the lens remains stationary. Since the lens remains stationary, the magnification of the image does not change. One must be very certain, however, that the back of the camera does not move when the film is inserted because this will change the focus. Unlike reflex cameras, the sheet film used in most view cameras can be exposed and developed one at a time, and can therefore serve as a test for subsequent exposures.

View cameras are usually capable of greater image magnification than single-lens reflex cameras because very short focal length lenses can be used in combination with very long bellows extension; single-lens reflex bellows are generally shorter.

Single-Lens Reflex Cameras

Single-lens reflex (SLR) cameras usually employ a mirror and prism system so that the image can be viewed and recorded on the film with the use of one lens. Thus, single-lens reflex, cameras enable the photographer to view the subject up to the instant of exposure. This feature becomes especially important when the subject is liable to move out of the area of focus. SLR cameras, being small and compact, are usually more convenient to handle and manipulate than view cameras.

STANDARD LENSES

In general photography, lenses of long focal length are usually required to give a large image of the subject from a given viewpoint. Surprisingly, in photomacrography, the reverse is true: for a given bellows extension, short focal length lenses will give greater magnification. For example, when the subject matter is at a distance twice the focal length of the lens, the image is life-size. If you have a 50mm (two-inch) lens, and you extend it 100mm (four inches) from the film, the image will be life-size. If you have a 100mm lens, it must be extended eight inches from the film before a life-size image appears. Accordingly, shorter focal length lenses take advantage of bellows extension.

When a 50mm lens is extended four inches to obtain a life-size image, the plane in focus will lie four inches in front of the lens. When a 100mm lens is extended eight inches to obtain a life-size image, an object will be in focus eight inches in front of the lens. In both cases, as the magnification is increased from life-size to larger-than-life-size, the subject will have to be moved closer to the lens. Therefore, in conditions of equal magnification, short focal length lenses will require the subject to be closer to the lens than longer focal length lenses. This demand for proximity with short focal length lenses can be a disadvantage if the subject is inconveniently located or if space is needed to arrange the lights.

In general photography, when the camera position is close to the subject, the parts of the subject near the lens appear very large when compared with parts that

are further away. Short focal length lenses can involve such small lens-subject distances. Thus, a photograph of a person with his feet in the foreground gives him the appearance of having tremendous feet and a small body. This characteristic of short focal length lenses also obtains in photomacrography: it will make near objects look larger than they are in proportion to the rest of the photograph. Longer focal length lenses will portray the proportions of the subject more accurately. However, perspective distortion should not be a major factor in your choice of lenses. This is because the depth of field is generally so small in photomacrography that differences in proportion are not easily noticed.

If you have several lenses for your camera and you are deciding which one to use, your choice should depend on three things: the degree of magnification you want; how much distance is needed between the lens and the subject; and the desirability of controlling apparent perspective distortion. As illustrated above, short focal length lenses will give greater magnification and will require the subject to be closer to the lens than longer focal length lenses. Longer focal length lenses reduce the tendency of close objects to appear unnaturally large, as compared with distant ones, because they involve greater lens-to-subject working distances.

Macro Lenses

Several manufacturers market a lens for 35mm cameras which can be focused from infinity to four inches, yielding a life-size image, with no attachments or, in some cases, with just one attachment. Such lenses are usually labeled "macro" or "micro" with the brand name of the manufacturer (Macro-Takumar, Micro-Nikkor, and so on). Most of these lenses give some indication of the changes in exposure that are necessary when the lens is extended. The Micro-Nikkor has an automatic diaphragm; many of the others are pre-set.

Except for the special macro lenses, attachments are often necessary to extend the lens so that the image on the negative will be life-size or larger-than-life-size. There are three basic types of these accessory attachments: close-up lenses, extension tubes, and bellows.

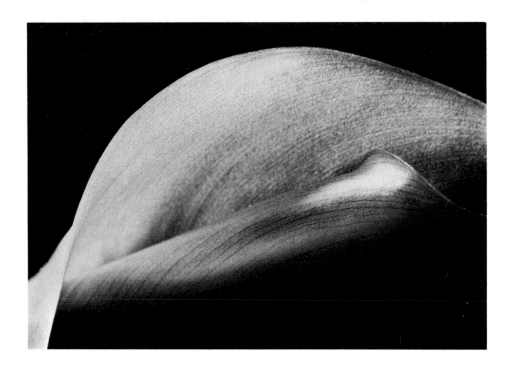

*Above and right: an unfolding leaf examined from different angles.
Bellows and a 55mm lens were used on a single-lens reflex camera
to make these photographs.*

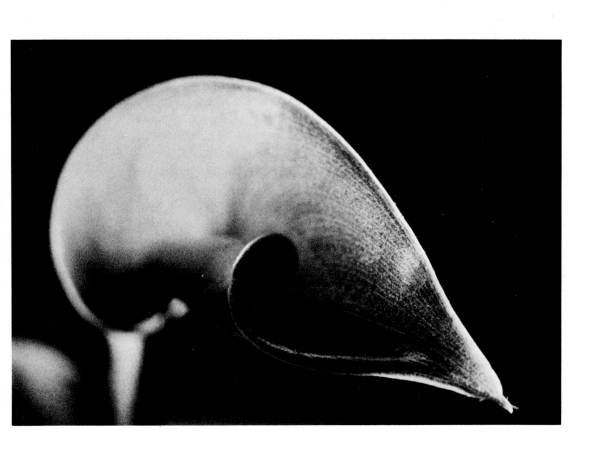

Close-up rings.

CLOSE-UP LENSES

Close-up lenses consist of one piece, or *element*, of glass and screw onto the front of the lens of the camera. They shorten the focal length of the camera lens to which they are attached. The photographer is able to work at closer ranges and obtain larger image sizes.

The main advantages of close-up lenses are utter simplicity, portability, and convenience. Since they must fit your camera lens exactly, they are available in different diameters and are also available with different degrees of magnification. Often close-up lenses are sold in sets of three, each lens having a different magnification, which can be used individually on the camera or in combination. When combining two close-up lenses, the higher numbered one should be closer to the camera lens. The use of more than two close-up lenses in combination is not recommended because of image degradation. The greater the numerical value of individual or combined attachment lenses, the closer the working distance (between the lens and the subject) and the greater the magnification.

There are two major disadvantages of close-up lenses. First, they tend to impair the quality of the image, especially around the edges, because they do not have the optical quality of camera lenses. To reduce the effects of lens aberration, the aperture can be set at a small opening, $f/11$ for example. Second, close-up lenses have very limited powers of magnification. Extension tubes and bellows usually magnify the image more than close-up lenses.

To increase magnification, close-up lenses may be used in combination with extension tubes or bellows. This will minimize the amount of lens extension to be used. Unlike extension tubes and bellows, close-up lenses do not significantly decrease the intensity of light that reaches the film. Therefore, when close-up lenses are used in combination with tubes and bellows, the magnification is increased while the exposure for the tube or bellows extension being used remains the same, and the lens does not need to be further extended. Thus, the possibility of camera movement during long exposures is decreased.

Even if you cannot remove the lens from your camera, you may nevertheless be able to attach close-up lenses to the front of it. If you cannot view the subject through the taking lens, be sure to measure accurately the distance between the subject and the center of the camera lens to make it correspond exactly to the point the close-up lens is focused on. Information on focusing should be included in the manufacturer's instructions for the close-up lens. If the distance is incorrect, the subject is likely to be out of focus.

EXTENSION TUBES AND RINGS

Extension tubes allow you to bring the subject close to the lens without increasing the focal length; however, a photographically useful image cannot be formed when the subject is closer to the lens than one focal length. For example, a 50mm lens will not form a photographically

Extension tubes.

17

useful image when the subject is less than 50mm in front of the lens, regardless of the close-up lenses, extension tubes, and bellows involved.

Extension tubes have no lenses and fit between the main lens and the camera body. They extend the lens-to-film distance, thus creating a larger projected image. Like close-up lenses, extension tubes sometimes come in sets and must be made to fit your camera exactly. Different combinations of tubes provide different magnifications, but the photographer is still limited to specified, pre-selected magnifications.

The amount of magnification with extension tubes and bellows depends on how far the lens is extended from the camera body. The further it is extended, the greater the magnification. The total magnification therefore depends on two things: the distance between the subject and the lens and the distance between the lens and the film. The closer the subject is to the lens or the further the lens is from the film, the greater the magnification, assuming the same focal length lens is being used.

Extension tubes are generally more expensive than close-up lenses and less expensive than bellows. Since they have no lenses, they cannot compromise the camera lens quality; however, they do not have the magnification versatility of bellows. Extension tubes can be used in combination with close-up lenses and/or bellows. Finally, extension tubes and bellows, unlike close-up lenses, require an increase in exposure to compensate for the increased distance the light must travel between entering the lens and reaching the film. These calculations will be explained in this chapter under "Exposure."

BELLOWS

Bellows are made out of flexible, collapsible, light-tight material. Like extension tubes, they have no lenses, they fit between the lens and the camera body, and they must fit your camera exactly. The great advantages of bellows are two: first, they offer complete versatility of magnification because they can be adjusted to any length; and second, bellows are generally longer than extension tubes and therefore extend the lens further from the film, thereby offering greater magnification.

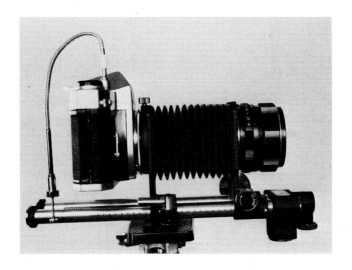

The greater the distance between the lens and the film, with either bellows or extension tubes or both, the greater the magnification, the longer the exposure, and the shallower the depth of field, assuming the focal length of the lens remains the same.

Many types of bellows have magnification and exposure scales engraved on the bellows rails for lenses of a specified focal length. Bellows for a 35mm camera would probably have engraved calculations pertaining to a 50mm lens. Most bellows may be extended either at the front end adjacent to the lens or at the rear end adjacent to the camera.

Perhaps it should be pointed out now that if you are going to use extension tubes or bellows you may have to stop down the lens manually. This is true even with some lenses that are automatic when they are used for general photography. If, for example, your exposure calls for $f/8$, you view and focus on the subject with the widest aperture of your lens so as to get the brightest image. Then close the lens down to $f/8$, review the background, and release the shutter.

Reverse Adapter

For photomacrographers interested in a higher-quality image, a reverse adapter can be used so that the front of the lens, rather than the back of it, is closer to the film. A better image is sometimes obtained in this way because most lenses were made for small

lens-to-film distances and large lens-to-subject distances; when this situation is reversed, the lens should be reversed. In addition to providing a higher-quality image, reversing the lens also permits longer distances between the object and the lens and seems to give better flatness of the overall image.

Most view camera lenses can be reversed without an adapter but present problems in changing shutter and aperture controls. This will be discussed more fully in Chapter Two.

LIGHTING

Pages upon pages have been written about lighting but all this discussion should be unnecessary. The photographer must look at how the light is affecting his subject and move the subject and the lights until the most pleasing results are obtained. All you need to remember is: look at the light on the subject!

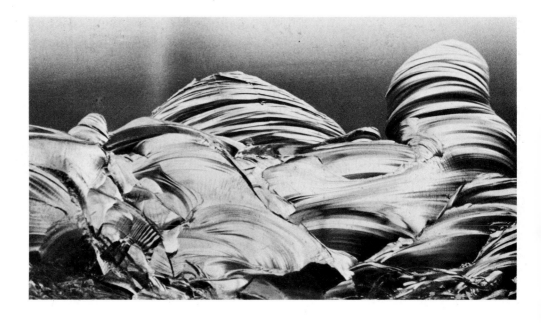

Below, left and right: chipped glass on an ashtray photographed twice life-size on the 35mm negative by natural light coming through a window. The ashtray was turned so that the light struck it at different angles, producing these effects.

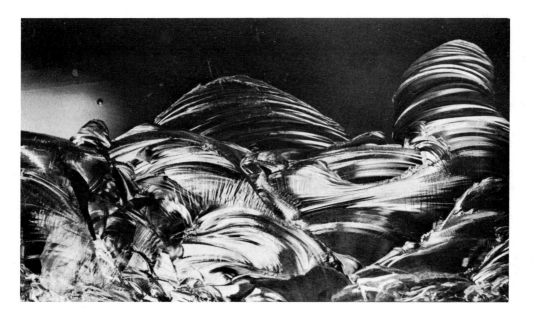

Artificial Light

The principles of lighting photomacrographic subjects are the same as for lighting general photographic subjects with a few added problems thrown in. The biggest problem is concentrating the light on small areas.

Ordinary light sources and flash spill light over a large area. This prevents sharp modelling because there is too much light coming from too many directions. Light beams can be shaped by putting cards with cutouts in front of the lamp. Small, high-intensity lights mounted on long arms that can be bent and swiveled to throw light from almost any direction are ideal for close-up work. They are available with light intensity controls and are balanced for different color films.

It is best to experiment with lighting until the best and most natural effects are found. Up to a point, the greater the angle between the light and the camera, in relation to the subject, the more shadows are created. For shadowless lighting the light source should be at the camera position. A ring light or ring flash around the lens is ideal for this purpose; shadowless lighting usually works well with color but may produce flat results in black-and-white.

The strategy of lighting depends on the subject and on the desired effect. With some subjects you may want uniformity of illumination; with others it may be desirable to bring out the form and texture by creating highlights and shadows. If shiny objects are illuminated with strong, direct light, distracting pure white highlights with no detail are likely to be formed. A dull, textured surface, on the other hand, may photograph best with strong, undiffused light.

Let us say that you wish to show texture in a subject. You will probably find that the raised parts of the subject are brightly illuminated and the lower parts of it are in deep shadow when the light is skimming over its surface. The texture should then be quite apparent, especially if a narrow beam of light from a flash or tungsten light is used.

Drain holes in a sink under photoflood illumination, right.

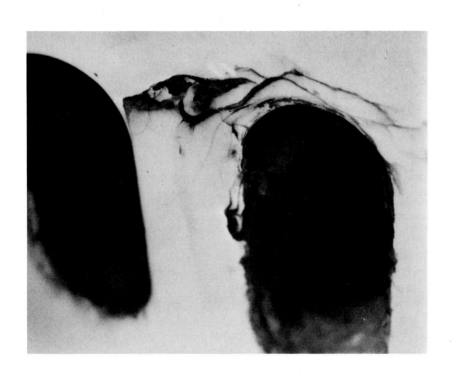

Light Boxes and Tents

For very diffused lighting, light boxes and tents are useful. The light box and the tent are enclosures, usually made of translucent material, within which the subject is placed. A cone of white paper, for example, can be made to fit around an object, with a hole at the top of the cone through which the lens will poke. The light is directed onto the surface of light box from the outside. This creates even, diffused lighting. The lighting can be made more directional by throwing more light on one side of the box than on the other.

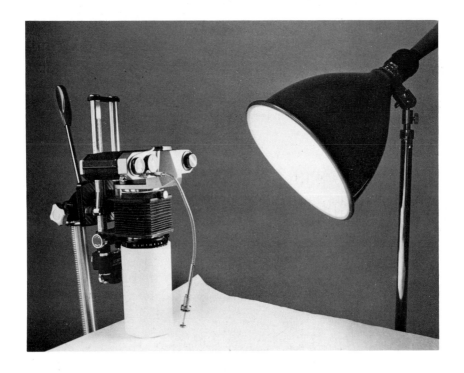

The light box setup shown above was used to take the top photograph on the opposite page. The bottom photograph is the same subject (cranberries) taken with natural, direct lighting.

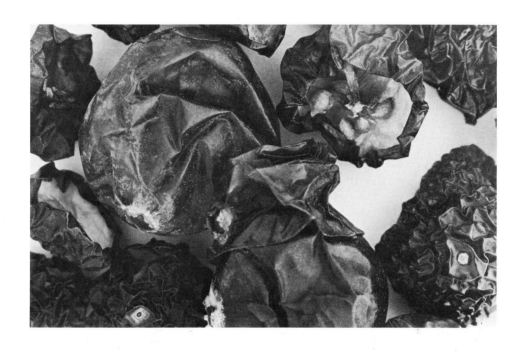

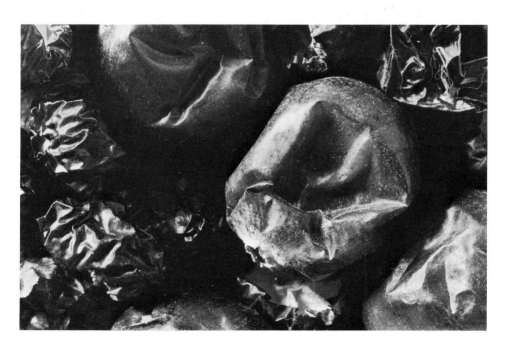

Backlighting

Many objects in photomacrography are opaque, and are illuminated from the front. To form silhouettes of opaque objects and to illuminate translucent objects, you can use backlighting. The subject is put on a piece of glass and the light source directed at a white card located behind the subject. The light hits the card, is reflected through the glass and the subject, and is cast into the camera. An alternate method is to place the light source itself behind the subject. Different effects can be achieved by moving the light around so that it is not directly behind the subject but shines through it at an angle.

Flash and Electronic Flash

Photoflood lights generate excessive heat and may warp, wilt, or shrivel some subjects. Electronic "strobes" and flash do not present this problem. They do, however, make it difficult to see how the subject will look before the picture is taken because it is hard to imagine how the highlights and shadows will form on the subject. The best way to overcome this problem is to use non-instantaneous lights to arrange the subject and focus the camera. Then replace the non-instantaneous light with the flashbulb or electronic flash, stop down the lens, and release the shutter.

The brightness and speed of instantaneous light makes it capable of stopping active subjects, prevents camera movement from being recorded, and permits the use of small apertures. As with other light sources, there is a problem of concentrating the light. The reflector around the flash is usually not adequate for this. Black paper taped around the reflector in a funnel-like shape may serve to direct the flash.

Guide numbers given by the manufacturer are not applicable because the bulb and reflector do not act as a point source of light at very close range. Special guide numbers must be derived from actual tests. Be sure that the instantaneous light you are using is synchronized to the shutter. This synchronizing information is usually included in the manufacturer's instructions.

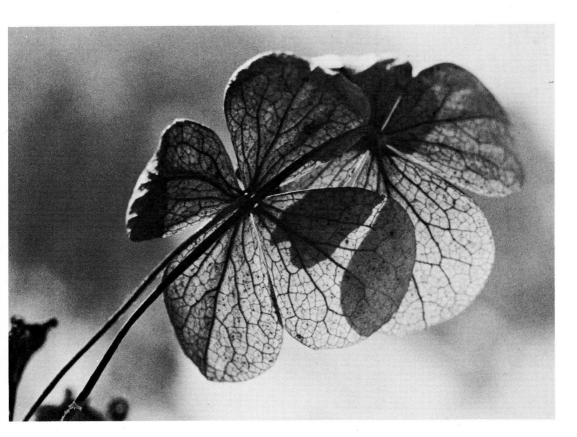

This picture of a plant was made using the sun as a backlight.

Photography Film
and Communication Studies Library
The Polytechnic of Central London
309 Regent Street W1R 8AL

COMMUNICATION LIBRARY, P.C.L.
18-22, RIDING HOUSE ST., W1P 7PD

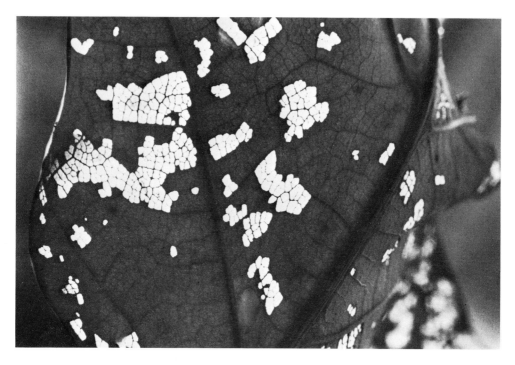

A decayed leaf: Daylight was used as a natural, diffused backlighting.

Keep in mind that light radiating from a point source in all directions decreases according to the inverse square law. At twice the distance from a light source, a subject is lit with one-quarter of the light. Therefore, if you move the light source from 5 feet to 2½ feet from the subject, the intensity of the light will be increased fourfold, not twofold as you may ordinarily think. This phenomenon can be compared to the image thrown on a screen from a slide or movie projector. The greater the distance from the projector to the screen, the larger the image on the screen; however, as the projector-to-screen distance increases, the image on the screen becomes less bright.

To find the guide number for your instantaneous light equipment with the type of light you are using, proceed as follows:

1. Measure the flash-to-subject distance.

2. Expose several frames of film using the instantaneous light; change the *f*/stop for each frame and record the frame number and the *f*/stop used on that frame.

3. Develop the film as you normally would.

4. Decide which negative is correctly exposed and find its corresponding *f*/stop in your records.

5. Multiply that *f*/stop by the flash-to-subject distance; the product is the guide number for that equipment and that film type.

The formula is:

Guide number = Distance multiplied by aperture

or

$$G = A \times D$$

If the correct aperture was *f*/16 and the distance was five feet, the guide number is 80. Using the formula, $G = A \times D$, *A* is 16 and *D* is 5. Therefore, $G = 16 \times 5$, so $G = 80$.

After the guide number for a particular flash or electronic flash is known, it is possible to calculate the correct distance for a given aperture and the correct aperture for a given distance. The following formulas apply:

$$D = \frac{G}{A} \text{ and } A = \frac{G}{D}$$

If the guide number is 80, and the aperture needed is *f*/8, the flash should be ten feet from the subject.

$$D = \frac{G}{A}, D = \frac{80}{8}, D = 10$$

If the instantaneous light is seven feet from the subject and the guide number is 80, the aperture should be *f*/11.

$$A = \frac{G}{D}, A = \frac{80}{7}, A = 11\tfrac{3}{7}$$

Lighting with Color Film

When accurate color fidelity is desired, the light source should match the color characteristics of the film. Normal daylight, electronic flash, and blue flashbulbs require daylight-type film. Regular photoflood lights require tungsten-type film; the exact type depends on the color characteristics of the light. Refer to the data sheet purchased with the film. The important thing to remember is that the film and the light sources must be matched. Even the reflecting surfaces must be chosen for their color neutrality unless special effects are to be achieved.

If the light sources do not match each other, the color will be unnatural and a filter may be required. Again the data sheet should specify the correct filter. In black-and-white photography the different light sources can be combined with no ill effects. However, due to the different wavelengths of light, black-and-white film is slightly less sensitive to artificial light than to daylight. If normally exposed and processed, artificial light situations may be underexposed on black-and-white film, but generally the latitude of the film will make these differences unnoticeable.

Reflectors

Reflectors serve to pick up light from any source and redirect it toward the subject. Reflectors can be highly directional or diffused, depending on the desired effect.

Polished reflecting surfaces, such as mirrors, can be masked or covered with cut-away paper designs in order to throw irregularly shaped beams of light. White cards can be used to direct light into broad, unrestricted areas of the subject.

Photoflood light was reflected from a white ceiling to prevent harsh highlights on the fork and spoon shown at right and on the following page.

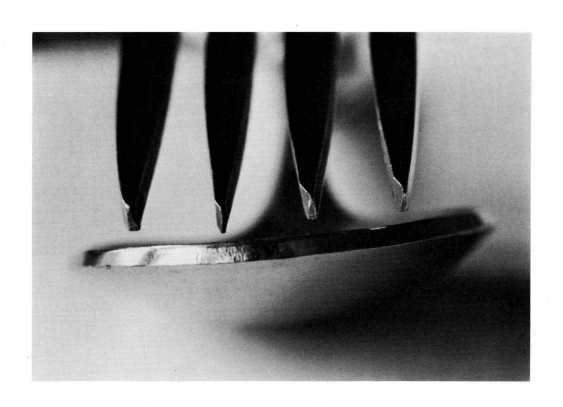

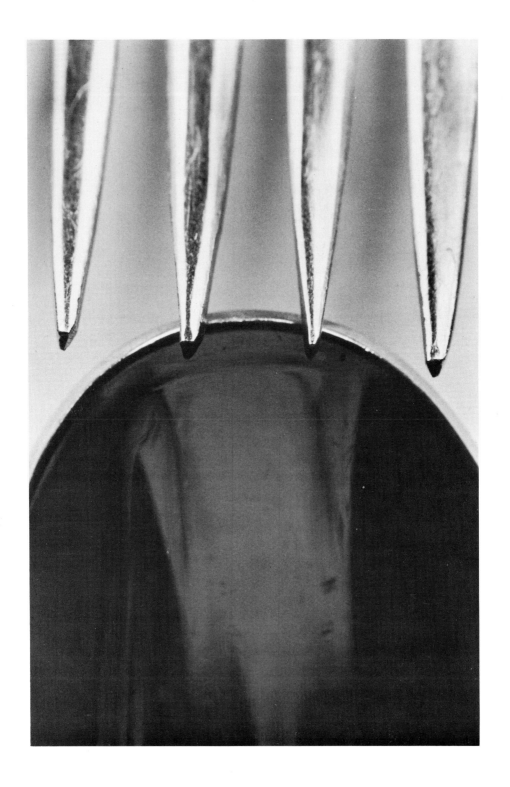

Natural Light

Photomacrography using natural light eliminates many artificial light problems but creates other problems. Direct sunlight tends to create hard shadows and harsh highlights. If this is undesirable, it is possible to use a reflector to bounce light onto the part of the subject in shadow or to place a diffusing screen (tracing paper, for example) between the sun and the subject to soften the highlights.

Also, since the light source, the sun, cannot be moved at will, the subject and/or the camera may have to be moved for the best lighting results. If this is inconvenient or impossible the dedicated photographer will wait for the sun to be where he wants it in order to light his subject in the best way.

Lens Flare

In both natural and artificial light photomacrography, lens flare can be a problem. Lens flare is caused by extraneous light directed into the lens. This creates glare or overexposed areas on the negative. To prevent this, avoid pointing the lens at a direct light source. The use of a lens hood also helps prevent flare. If you have reversed the lens, the hood may not fit and you will have to improvise with black paper held around the lens with masking tape. In this way extraneous light rays will be prevented from entering the lens.

To avoid flare with backlighting, a diffusing screen can be put between the light and the subject. If the subject fills up the entire frame, direct light will probably not enter the lens. On the other hand, you may not always want to eliminate lens flare; in some pictures it may be aesthetically desirable.

These apertures were photographed by opening the back of an unloaded SLR camera and setting its shutter at "T." This allowed light to pass through the back of the camera and through its lens. Another camera, fitted with a macro lens, was aimed into the lens of the first camera. From top to bottom: ƒ/2.8, ƒ/4, ƒ/5.6, ƒ/8, and ƒ/11.

EXPOSURE

To begin with, there is a basic relationship between the shutter and the aperture. The shutter controls the length of time light is allowed to reach the film. The aperture, or diaphragm, controls the quantity of light that reaches the film and is designated by numbers known as f/stops. The designations f/16, f/11, f/8, f/5.6, f/4, and f/2.8 are typical f/stops. The larger the number, the smaller the opening of the aperture. Therefore, the larger number settings of the aperture will allow less light to reach the film, assuming the shutter speed remains the same. Between each consecutive full f/stop, the intensity of light is either halved or doubled. In other words, if the f/stop is changed from f/16 to f/11, the quantity of light allowed to pass through the lens has been doubled. From f/16 to f/8, it has been quadrupled; from f/16 to f/5.6 it has been increased eight times.

If the aperture is kept the same and the shutter speed is increased or made faster, then once again less light reaches the film. Typical shutter speeds are 1/30 sec., 1/60 sec., 1/125 sec., 1/250 sec., and 1/500 sec.

On many cameras, the shutter speeds and f/stops correspond in such a way that when one is raised and the other lowered, the same amount of light reaches the film. Therefore, if the shutter speed is made twice as fast and the aperture is opened one stop, the same amount of light reaches the film. This is because the length of time the light is allowed to reach the film has been cut in half, but the quantity of light reaching the film has been doubled. Based on this relationship between the shutter speed and the aperture, if the correct exposure is 1/60 sec. at f/5.6, the exposure will be equally correct if it is changed to 1/30 sec. at f/8, or to 1/15 sec. at f/11, or to 1/8 sec. at f/16. However, shutter speeds of one second or longer present a problem of reciprocity failure, which, unfortunately, changes the nice aperture-shutter speed relationship. Reciprocity will be discussed shortly.

In photomacrography, exposure is a tricky business. Theoretically, if all the tones in an average scene are combined the result will be a neutral gray. A light

meter, built into the camera or handheld, is made to give a reading based on this neutral gray. All films have a limited ability to tolerate variations in the intensity of light and still give acceptable results, called their *latitude*. If an average gray tone can be made to fall within the film latitude, then highlights and shadows may be recorded and good tonal reproduction achieved.

There are two ways to find the required camera settings for neutral gray in a given lighting situation: one is to measure the light reflected by the object, called the *reflected light reading*, and the other is to measure the strength of the light source, called the *incident light reading*.

Reflected Light Readings

Reflected light readings are taken by aiming the meter in the camera or a handheld one at the subject. Problems arise when a reading is taken of an area in which the tones are not average. In other words, if all the tones were combined, the result would be a dark or light shade of gray rather than a neutral gray. The light meter, ignorant of the situation, would continue to assume that the scene was average and it would give fallacious readings that would over- or underexpose the film. If, for example, one takes a normal light reading of a white wall, exposes the film as indicated by the meter, and develops normally, the white wall will be underexposed and therefore appear gray. If the same procedure is followed for a black wall, the resulting negative will be overexposed and will also appear gray. We must therefore never rely on our light meter to do our thinking for us, but rather compensate for it when the scene we wish to portray is not average, or when our subject is lighter or darker than average.

In photomacrography it is usually best to bring the meter close to the subject to eliminate extraneous light. Care should be taken that the shadow of the light meter does not fall across the area being read. Nevertheless, corrections on light readings will be necessary. This is because the objects magnified do not usually have average tonal ranges. Many times there are wide expanses of light or dark areas that must be compensated for. Unfortunately, there is no foolproof way to get the

Left: Black appears gray when the exposure reading is based on black paper. Center: An exposure reading based on a gray card produces normal tones. Right: When the exposure reading is based on white paper, white appears gray.

correct camera settings. One method is to take a normal reading of the subject, correct this reading for the overall tones of the particular object, and then take several pictures with different aperture or shutter speed settings. If the object is lighter than neutral gray, the exposure is increased from what the meter read, and vice versa. For example, if the subject is an overall cream color, and the meter read 1/30 sec. at $f/11$, the shot should probably be bracketed by exposing at 1/15 sec. at $f/11$, at 1/8 sec. at $f/11$, and perhaps 1/4 sec. at $f/11$. This method does tax film resources but it is one way to insure correctly exposed negatives. As one's facility for correcting the meter readings increases, fewer shots will be necessary to arrive at the perfect exposure.

This system of making a meter reading, correcting it mentally, and taking several pictures will work with handheld meters and through-the-lens averaging

meters in single-lens reflex cameras. If you have a spot meter you can take a reading of an area with average tonal ranges, which is the equivalent of neutral gray. However, this average tone is often difficult to find. Another method is to take a reading of the shadow area, then a separate reading of the highlight area, and average the two readings, still correcting if the scene has above or below average brightness. Some through-the-lens meters that normally work at the widest aperture of the lens will have to be stopped down when they are used for photomacrography.

The Neutral Gray Card

Much guesswork can be avoided if a neutral gray card is used to make light readings. A neutral gray card is merely a piece of cardboard that is coated on one side with the neutral gray tone referred to earlier. Commercially made cards are available in many camera stores; Kodak sells one called the Neutral Test Card. Place the card so that the same intensity of light that falls on the subject falls on the card. It must be positioned so that it is parallel to the surface of the subject. A meter reading can then be made of the gray card. If you use this method you may want to bracket at first, making exposures under and over the given exposure, as well as on the button. For example, if the meter reading from the gray card is 1/15 sec. at $f/11$, the shot can be bracketed at 1/15 sec. at $f/8$, at 1/15 sec. at $f/11$, and at 1/15 sec. at $f/16$ to insure the correct exposure. It could also be exposed at 1/8 sec. at $f/11$, at 1/15 sec. at $f/11$, and at 1/30 sec. at $f/11$. The latitude of the film should influence the amount of bracketing that is done. Bracketing should be more extensive when the exposure must be accurate, that is, when the film has narrow tolerance for incorrect exposures.

Above, right: Kodak Photo-Flo wetting agent in a black development tank photographed at 1:1 magnification with skylight illumination. Below: paint dabs on a plastic bottle top photographed with daylight illumination.

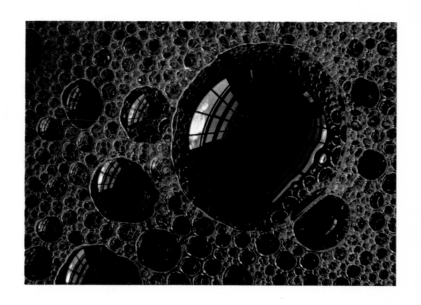

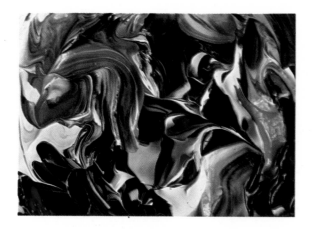

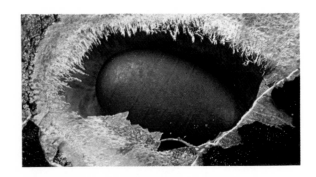

Seed pod photographed at 1:1 magnification.

Grapes photographed by daylight illumination and underexposed for deeper color saturation.

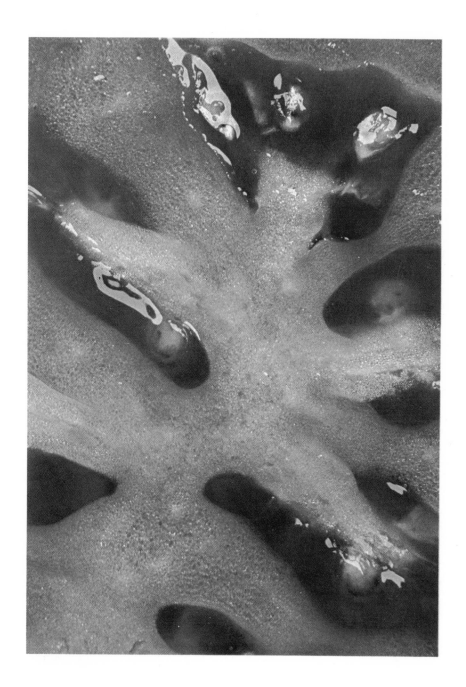

Tomato slice.

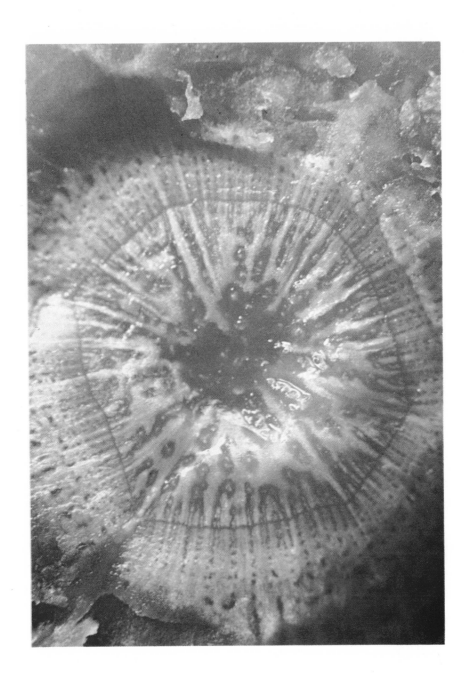

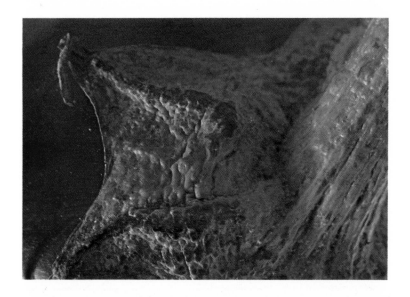

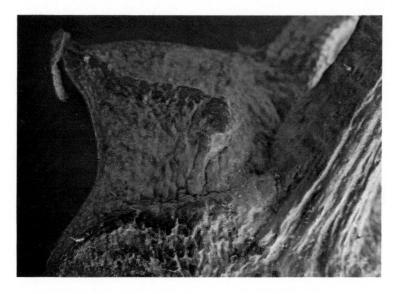

The stem of an egg plant photographed on film balanced for daylight (sunlight plus skylight). For the top photograph a photoflood light was used. The bottom photograph was made using skylight illumination.

Left: a carrot slice photographed at 1:1 magnification.

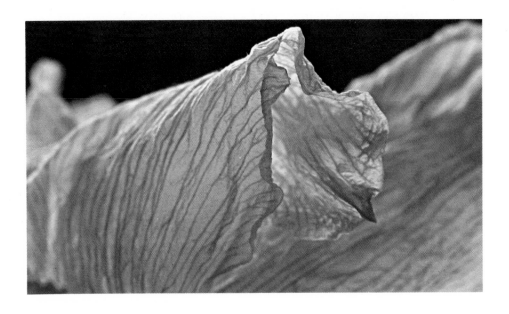

Above: dried flower petals photographed against a black background.

Right: a partially dried artichoke heart. As the subject aged, deep purple hues developed.

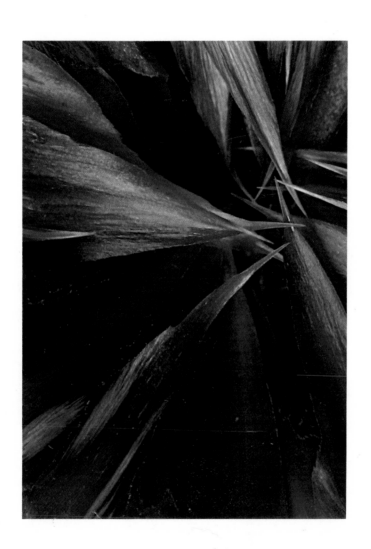

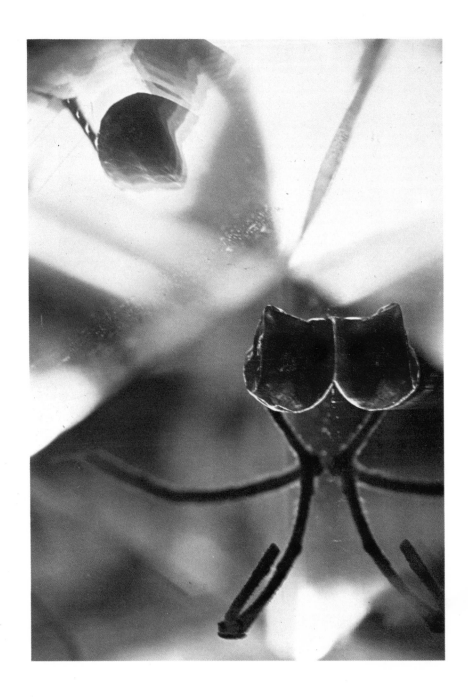

Mirrors and a berry: The berry was placed on a mirror lying on a table. Then two mirrors were placed above the berry to form a pup-tent-shaped enclosure that reflected the berry from the bottom and sides.

Calculating Changes in Exposure

From the preceding paragraphs it may seem that through-the-lens meters will give the same results as handheld meters. This is often not the case. Separate meters do not calculate for the increased distance the light must travel between entering the lens and reaching the film through extension tubes or bellows, whereas some, but not all, through-the-lens meters do. The light spreads out when it travels this increased distance between the lens and the film according to the inverse square law discussed above. The meter in the camera can calculate this feeble light, but the handheld meter will not compensate for the increased distance. The formula for calculating the changed exposure for handheld meters is called the *bellows factor formula*. This formula should be used for relative accuracy whenever the subject is closer to the lens than eight times the focal length of the lens.

$$\frac{\text{Bellows extension}^2}{\text{Focal length of the lens}^2}$$

The *bellows extension* is the measured distance between the lens and the film; the lens should be measured from its center. The *focal length of the lens* is usually written on the front of the lens (50mm, 55mm, 105mm, and so on). As indicated by the formula, the bellows extension and the focal length should each be squared. The quotient of this formula is the factor by which the exposure has to be corrected. A factor of one indicates no change in exposure. A factor of two indicates increasing the exposure by one *f*/stop or by one shutter speed calibration. A factor of four indicates increasing the exposure by two *f*/stops or by two shutter speed calibrations, and so on. This factor–exposure change relationship works because there is a doubling or halving of light between consecutive apertures and between consecutive shutter speeds.

If you are using a 50mm lens and the distance from the lens to the film plane is 100mm, the bellows factor would be:

$$\frac{B^2}{F^2} = \frac{100^2}{50^2} = \frac{10,000}{2,500} = 4$$

Four is the calculated factor. If your meter read the gray card (or an object with average tones) as 1/60 sec. at $f/8$, then the exposure factor of four from the extended bellows makes the correct camera setting 1/15 sec. at $f/8$. A factor of four would mean an increase in exposure of two shutter speed calibrations. As an alternative, a factor of four could mean an increase in exposure of two $f/$stops. Using the example above, the new camera setting would be 1/60 sec. at $f/4$. Fast shutter speeds should be used to stop action: *e.g.*, 1/60 sec. at $f/4$. Small openings should be used to obtain greater depth of field: *e.g.*, 1/15 sec. at $f/8$ or 1/8 sec. at $f/11$. The bellows factor formula can also be calculated using inches instead of millimeters.

There are other ways to figure out how much to correct the exposure. Many bellows rails have engraved exposure calculations. Below is an exposure factor table for bellows that do not have calculations. It can also be used for extension tubes and rings. This table is valid regardless of which focal length lens is being used.

Ratio of size of object on negative to life-size	Exposure factor	Increase in $f/$stops
1:1	4	2
2:1	9	$3^{1}/_{4}$
3:1	16	4
4:1	25	$4^{3}/_{4}$
5:1	36	$5^{1}/_{4}$
6:1	49	$5^{1}/_{2}$
7:1	64	6
8:1	81	$6^{1}/_{4}$
9:1	100	$6^{3}/_{4}$
10:1	121	7

The only problem here is comparing the size of the object on the negative to the real object. There is a simple formula for this:

$$\text{Magnification} = \frac{\text{Distance between lens and film}}{\text{Distance between lens and object}}$$

It is difficult to measure this distance with precision, but if the distance between the lens and the film is eight inches and the distance between the lens and the subject is four inches, then the magnification is two.

The size of the object on the negative is, therefore, twice life-size:

$$\text{Magnification} = \frac{8}{4} = 2$$

One of the easiest methods by which to figure out exposure changes for 35mm SLR cameras is to use the little ruler presented here:

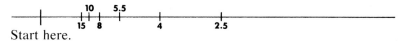

Start here.

Calculated for a viewfinder that encompasses 10% less area than is recorded on the negative.

Copy the ruler and place it in the subject position. Then, looking through the camera viewfinder at the ruler, align one edge of the frame to the "start here" mark. The number at the other edge of the frame, horizontally positioned, will indicate the exposure factor. If, for example, the area included in the picture measures 1½ inches long at the subject, the exposure factor is four and the exposure indicated by a meter should be increased two f/stops or two shutter speed calibrations. The Kodak *Master Darkroom Dataguide* has another ruler that can be used with any camera with groundglass viewing.

Incident Light Readings

To make incident light readings a white plastic cone attachment usually has to be placed on the light meter. In general, meters built into the camera are not suitable for incident light readings.

The meter, with attachment, is put near the subject and aimed at the camera. Readings taken in this way must still be corrected for the bellows extension.

Reciprocity Failure

In extremely long exposures, the effective speed of the emulsion is reduced, and the image on the negative will be underexposed if it is given an exposure calculated in a normal way. The failure of the reciprocal relationship between time and intensity in affecting exposure is known as the failure of the law of reciprocity.

To us in photomacrography, this means that if we have an exposure of longer than approximately one second, we must refer to reciprocity tables to compensate for the failure of our film to obey the laws of reciprocity. Kodak distributes a data sheet with complete information on reciprocity; some general, average factors for black-and-white films are given below. (These factors actually change for different types of films.) To use them, multiply the exposure time indicated on your light meter by the corresponding factor, and you will have the correct exposure time. Reciprocity corrections must be made on light readings from handheld meters and meters inside the camera.

If you have bellows factor correction in addition to reciprocity factor correction, it is important to remember that one factor must be multiplied by the other for the final exposure factor. There are some examples following which can alleviate the confusion you may be experiencing.

Reciprocity Table for Black-and-White Roll Films

Exposure time (sec.)	Approximate factor	Exposure adjustment increase (f/stop)	Development adjustment
1	1.25	¼	none
10	2.0	1	none
100	4.0	2	10% less

Malaysian cowry shells photographed under natural (daylight) illumination.

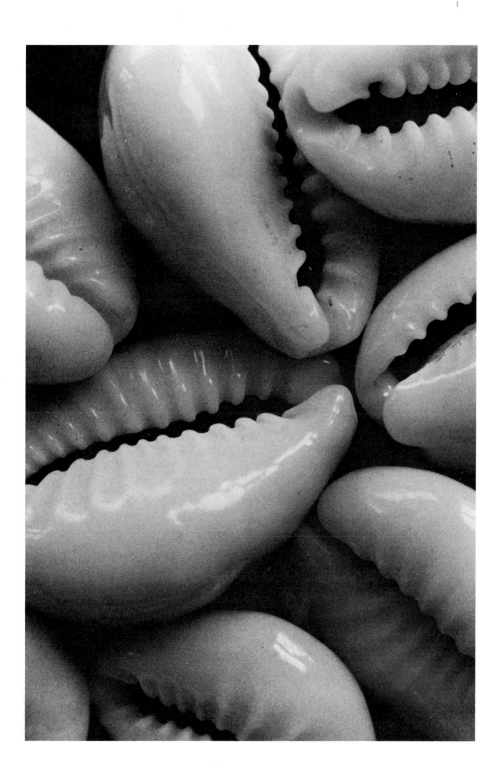

If you are taking a life-size photomacrograph you will have a bellows factor of four. If the normal light reading is $f/11$ for ten seconds, for example, then the reciprocity factor according to the table above will be 2.0. These two factors multiplied produce a total factor of eight (2.0 × 4). The new exposure would be 80 seconds at $f/11$; from 10 seconds to 20 seconds would be a factor of two, from 10 seconds to 40 seconds is a factor of 4, from 10 to 80 is an exposure factor of 8.

Long exposures also affect the contrastiness of a film. An adjustment in development is necessary to compensate for the change in contrast. The exact amount of adjustment can be obtained from the data sheet for the film being used. Some average adjustments are given with the reciprocity table above.

If your exposure factor is nine (the image size is twice the subject size) and the normal meter reading is $f/16$ at 1/8 sec., you may decide to expose the film at $f/11$ for 1/2 sec., in which case there may not be any reciprocity factor; or you may expose it at $f/16$ for one second. In this case the reciprocity factor would be about 1.25; the corrected camera settings would then be approximately 1½ seconds at $f/16$.

Handheld Light Meter

Reading .$f/16$ for ⅛ sec.
Bellows factor .9
 $f/16$ for ⅛ sec. = factor of 1
 $f/16$ for ¼ sec. = factor of 2
 $f/16$ for ½ sec. = factor of 4
 $f/16$ for one sec. (or $f/11$ for ½ sec.) = factor of 8
Reciprocity factor .1.25
Final exposure .$f/16$ for 1½ sec.

The reciprocity table does not apply to color films. The three emulsions on color film have different speeds and are affected differently by reciprocity failure. With color films changes are required not only in

camera settings but also in the balance of the three layers. It is possible to correct this imbalance with filters. Kodak's *Master Darkroom Dataguide* specifies which filters to use with Kodak color films. It is even possible that you will find that the inaccurate color rendition adds to, rather than detracts from, the picture.

It is a remarkable fact that between $f/16$ and $f/2.8$, 32 times more light is admitted through the diaphragm of the lens. By the same token, a shutter speed of one second admits 30 times the light admitted by a shutter speed of 1/30 sec. The two groups of settings do not quite correspond, but in practice increasing one and decreasing the other by one setting will give you the same exposure.

To put it another way, an exposure factor (or bellows factor) of 32 can be met by opening the diaphragm up five $f/$stops, for example, from $f/16$ to $f/11$ to $f/8$ to $f/5.6$ to $f/4$ to $f/2.8$; or by increasing the shutter speed, for example, from 1/30 sec. to 1/16 sec. to 1/8 sec. to 1/4 sec. to 1/2 sec. to one second. This is because between one opening and the next largest opening, the light passing through the lens is doubled, making an exposure factor of two. Between six $f/$stops there is $1 \times 2 \times 2 \times 2 \times 2 \times 2$, or 32 times, as much light passing through the diaphragm of the lens; between six shutter speed settings there is 30 times as much light.

One Final Word on Exposure

Fortunately most films will tolerate a slightly inaccurate exposure and still produce a usable negative.

DEPTH OF FIELD

Depth of field refers to the nearest and farthest parts of the subject that can be brought into acceptable focus on the film at the same time. The depth of field depends on the aperture of the lens and on the magnification. The aperture of the lens affects depth of field in photomacrography just as it does in general photography, *i.e.*, the wider the aperture, the shallower the depth of field. The greater the magnification, the shallower the depth of field.

Dried pea soup in a spoon taken using different f/stop–shutter-speed combinations. From left to right: f/2.8 at 1/1000 sec.; f/5.6 at 1/250 sec.; f/16 at 1/30 sec.

In photomacrography depth of field is extremely shallow, because the lens is close to the subject and the magnification is great. To compensate for this to some extent, the lens diaphragm can be stopped down to small openings. Inevitably, this presents a problem. The use of extremely small openings will reduce the resolving power of the lens and may impair the image because the light is diffracted as it passes by the edges of the diaphragm of the lens. Optimum results are obtained between the largest and smallest openings of the lens. Very small openings also require either long exposures or a lot of light or both.

When the lens is stopped down as far as it will go, there is only one way of getting greater depth of field. That is to reduce the size of the image. The image size can be reduced by decreasing the lens extension,

in other words, by making the lens-to-film distance smaller.

If maximum depth of field is desirable, use as little magnification as possible and stop down the lens to its smallest opening.

Focusing in photomacrography is not as easy as in general photography. Focusing the lens in the normal way will actually change the magnification, as will moving the bellows, because the film-to-lens-to-object distances are altered. The best focusing procedure is to leave the camera and lens stationary and to move the subject into focus. If it is inconvenient or impossible to move the subject, the next best way to focus is to move the entire camera–lens setup forward or backward. You will find that a fraction of an inch will make a great deal of difference to the focus.

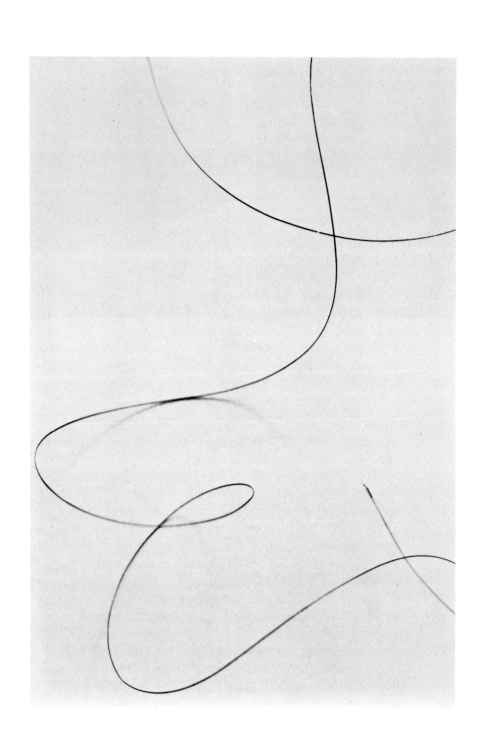

FILM

In choosing the film most suitable for your needs and conditions, you should be aware of its speed, contrast, definition, and latitude, all of which are inherent characteristics of film.

Film speed refers to its sensitivity to light; different films respond differently to the same amount of light. A film's relative sensitivity to light is measured by its ASA rating; the larger the number, the less light needed to expose the film. There is a direct relationship between ASA numbers: a film with a speed of ASA 200 is twice as sensitive as a film with an ASA rating of 100.

In general, the slower the film, the more contrast it will have, or in other words, there will be a greater proportion of black and white areas than gray areas.

Definition involves resolving power, acutance, and grain. Resolving power is the ability of the film to reproduce fine lines and is generally better in slow rather than fast films. Acutance refers to the film's sharpness or ability to record a knifelike edge between light and dark areas; it is also better with the less sensitive films. Grain is the clumping together of black metallic silver to form tiny dots, which work together to form an image. The faster the film, the coarser grain it will have.

With all these factors in mind, remember that a fast film has the shortcomings of graininess, low contrast, and relatively poor resolving power and acutance. However, fast films enable us to use faster shutter speeds and smaller apertures so we can avoid movement and unmanageably shallow depth of field. Some examples of fast films, with ASA ratings from 250 to 1250 are: Agfa Isopan Record, Agfa Isopan Ultra, Ansco Super Hypan, Ilford HP-4, Kodak Tri-X, Kodak Royal X Pan, and Kodak 2475 Recording Film.

Left: A human hair photographed on Tri-X film and developed in D-76.

OTHER ACCESSORIES

It is common in photomacrography to use exposures longer than 1/30 sec. The camera is usually very clumsy with the accessories attached to it for photomacrography. Unfortunately, not only is the object magnified, but any movement of the object or the camera setup is magnified as well. Therefore, some sort of stable support for the camera and the subject is warranted. It is possible to rest them on tables or floors or a pile of telephone books, but it is much more convenient and easy to manipulate a camera when it is on a heavy, solid tripod, and if you haven't already, you may find a tripod to be a worthwhile investment.

Ball-and-socket heads and pan-tilt heads for tripods such as are used in motion picture photography will be found invaluable in making lateral and vertical adjustments in the position of the camera. If you are using bellows, it may be possible to loosen the camera end of the bellows in order to change the camera angle slightly for a more pleasing composition.

With or without a tripod, a cable release is very important to be sure that your camera is steady at the instant of exposure. No matter how immobile the camera appears to be, pushing the shutter with your finger instead of the cable release may move it enough to blur the photograph. An alternate method is to use the self-timer to avoid movement during the exposure.

The main purpose of subject supports is to hold the subject rigidly in position to be photographed. Some rather unsophisticated bits of hardware may be used to hold objects in place, including tape, pins, clay, and anything else that might spring from an ingenious or desperate imagination. Working at very close ranges, depth of field is so shallow and subject coverage so limited, supports for small objects can be placed so that they fall completely out of view.

Right and page following: a walnut at 1:1 magnification.

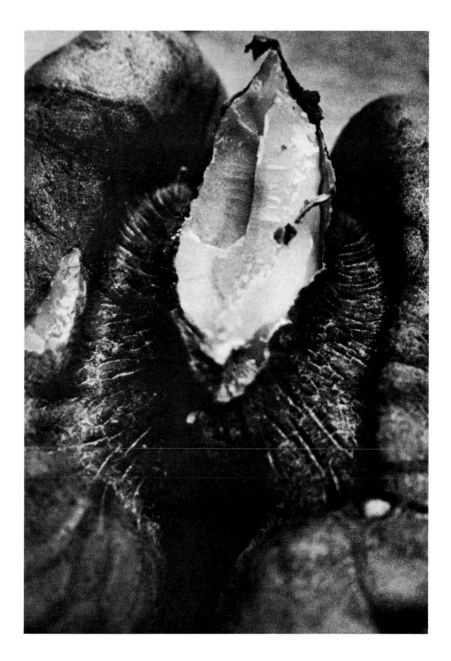

Photography Film
and Communication Studies Library
The Polytechnic of Central London
309 Regent Street W1R 8AL

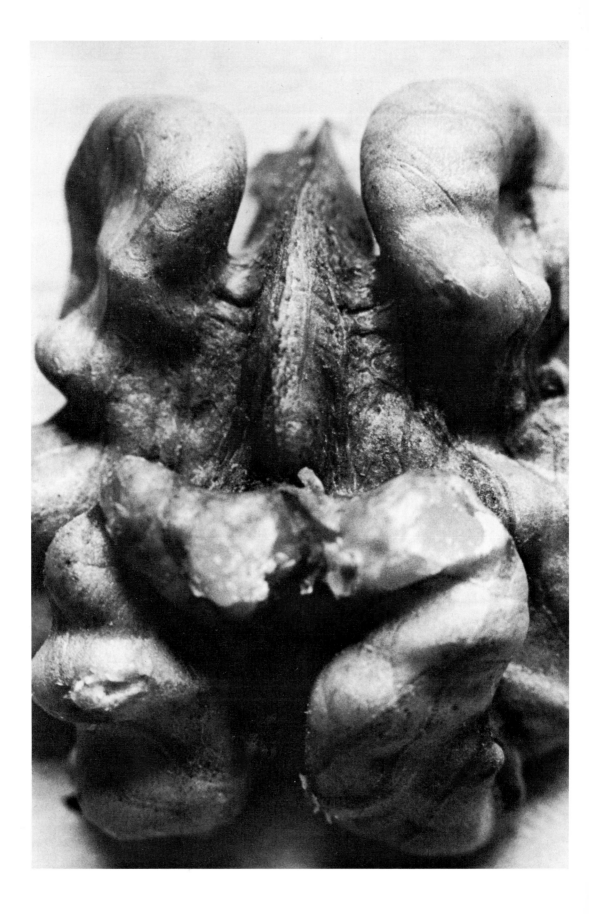

2

Subject Matter

Anything and everything provides a potential subject for photomacrography. Of course, some things lend themselves to artistic, imaginative, and useful pictures more readily than others, and some things are easier to take pictures of than others.

TWO-DIMENSIONAL SUBJECT MATTER

The best way for a beginner to start in this field is to take pictures of two-dimensional objects. In this way the great depth-of-field hassle can be avoided. Blossoming photomacrographers are then free to concentrate on learning the knobs and dials of their equipment, and the whys and wherefores of exposure.

Two-dimensional objects are plentiful and two-dimensional photography is not as restricting as it sounds. For example, the world of philately lies within two dimensions. If stamps do not appeal to you however, keep in mind that anytime a solid is cut with a sharp knife or broken cleanly, it becomes, for our purposes, two-dimensional on the side that is cut and may be an exciting discovery beneath a macro lens. Food such as carrots, cabbages, and tomatoes can be cut in this way while rocks can be broken to reveal their fascinating structures. Should a three-dimensional object not have a flat surface it may be possible to flatten it. Although flattening is not a recommended procedure for valuable objects, it can work satisfactorily with leaves, feathers, and the like.

Other examples of two-dimensional subject matter for your consideration are fabrics. Cotton, wool, and corduroy are kinds that may be effectively lit from behind, and they may be appealing in color.

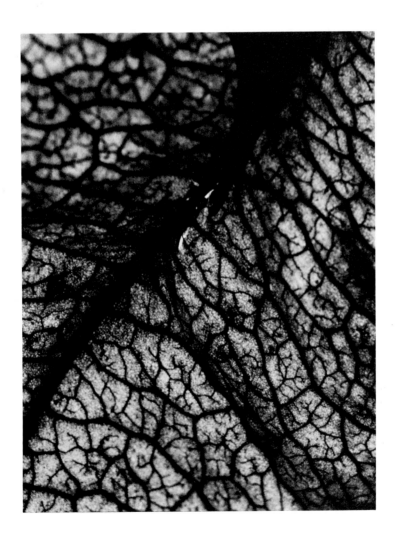

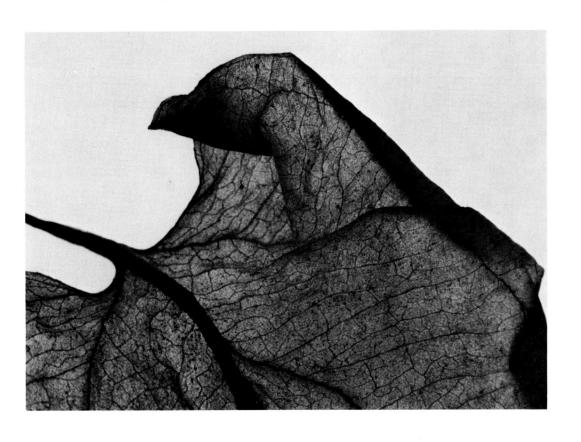

These leaves were photographed before flattening using photoflood backlighting.

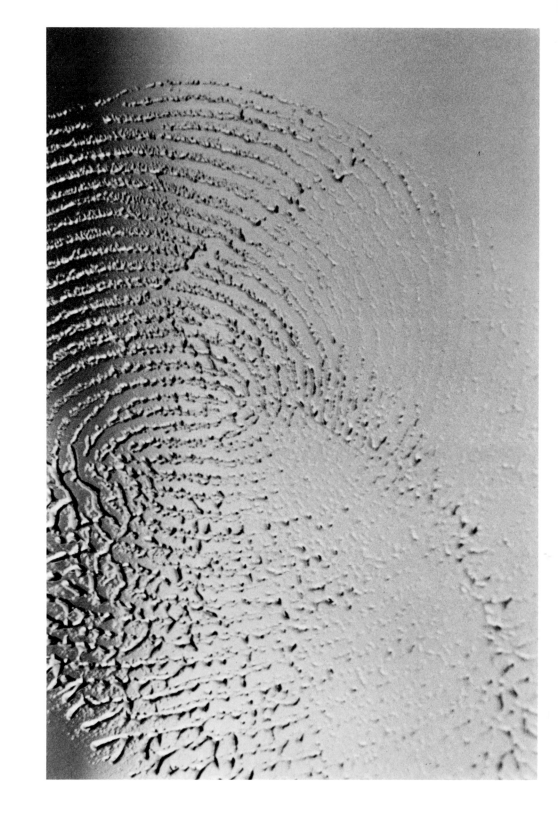

Liquids

Moving from subjects that, practically speaking, only have length and width, there are those that have slight depth. A challenging subject in this category is liquids.

If anyone in your home is interested in chemistry and has chemicals to prove it, try appropriating some in the interests of photography. You will have opened a kingdom for investigation. It might be a good idea to persuade the chemist in the family to tell you which chemicals explode when combined with which other chemicals so that you do not get discouraged by unfortunate mishaps.

You can experiment with solvents besides water. Oil, for example, can be used alone or mixed with water. You are sure to create, at one time or another, some intriguing colors or designs.

Before mixing the chemicals set up your macro equipment, make exposure calculations, and focus.

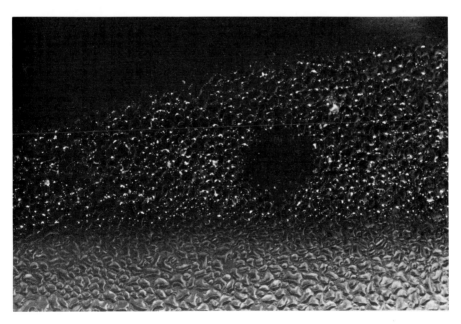

Above: condensed moisture on a kitchen window. The negative was printed on Agfa Brovira No. 6 paper for high contrast. Left: Crosslighting was used to make this photograph of a vaseline fingerprint on glass.

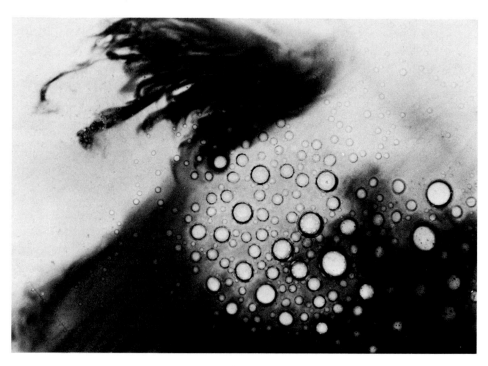

Chemicals dispersed in a thin film of water on the bottom of a paper cup.

Then all you have to do is turn on the lights and release the shutter. If you do not have the paraphernalia ready, and you have to cock the camera or set the aperture, you may find that your beautiful reaction has reacted before you did.

Despite your preparedness the chemicals may move while the picture is being taken. A shutter speed of 1/30 sec. will usually be fast enough to stop this action from being recorded on the film. If the liquid is shallow, the opening of the diaphragm will not have to be very small to achieve sufficient depth of field and therefore a 1/30 sec. shutter speed should be feasible.

At times you may find that although the surface of the liquid was in focus, the bottom of it was not, or that the chemicals were too active and resulted in a blurry image. With a little experience such troubles can be overcome. These troubles may even turn into pleasant surprises. You may sometimes like the effects of selective focus and blur due to movement. Be willing to experiment and try anything that comes to mind, even if rules are broken.

Other possible liquids that may already be in your home are paints. Mixtures of paints may make very

colorful pictures. Try mixing an insoluble liquid with the paint (water or oil) to create designs that could be exciting in black-and-white. If you are searching for still other photogenic liquids, keep in mind that some normally solid substances, butter, for instance, can be melted to a liquid.

While photographing liquids, you will often place the camera in a vertical position. This may be awkward if you have a heavy camera or a weak tripod. Be prudent and test your equipment in this position before attempting any pictures with it. I can testify that it is a disheartening and unnerving experience to have a camera with all its accessories fall lens first into a newly created liquid.

Assuming that the camera can be put in a vertical position, the next step is to make it parallel to the surface of the liquid. In photomacrography this parallelism is very important. Both the lens and film plane must be parallel to the subject. If they are not, an unnecessary depth-of-field problem will have been created by having one part of the subject closer to the film than another part of the subject.

I have found that one of the best places to photograph liquids is on the top portion of an inverted paper cup. This is useful for two reasons. First, it prevents you from wasting great quantities of the substance you are using. Second, the paper transmits and diffuses light. The cup can be placed on glass and the liquid lit from the bottom. Many times bottom light is most effective when it is the only light used. Another advantage of paper cups is their disposability. The liquid mixtures that avid photomacrographers create cannot always be removed from the surfaces they are made on. Be sure that whatever you put on paper cups is not caustic to paper.

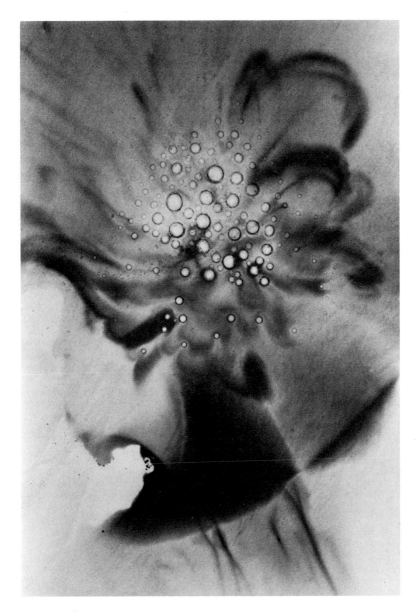

Chemicals in water.

THREE-DIMENSIONAL STILL SUBJECTS

Still subjects can be photographed with either view or single-lens reflex cameras. They present a situation in which you may like to try reversing the lens for better image quality.

If the lens is put in backwards on some view cameras, the shutter will be inside the camera. However, a shutter is not necessary for this work when exposures of ten seconds or longer are used. You can cover the lens with a black card, remove the card for the duration of the exposure, and replace it in front of the lens until the slide is over the film.

The shutter operation can also be performed manually with view and SLR cameras when instantaneous light is employed. Most SLR cameras have a "B" or "T" setting to hold the shutter open. The room is darkened to prevent unwanted light entering the lens; the flash or strobe is set off manually, and the shutter is closed in SLR cameras or the slide is replaced in view cameras. The flash can easily be set off several times from different positions to light the subject from all sides. Make mental notes on which parts of the subject have already been illuminated and which have not so that one area of the subject will not be overexposed and another area underexposed. Unless uneven lighting is preferred, keep the light the same distance from the subject for each flash.

To attain the best quality, bear in mind that the subject must be set up firmly in front of the lens and the camera and tripod rooted to their position. The slightest movement will require refocusing. Focus on the segment of the subject you have decided is most important.

One of the nicest advantages to photographing still subjects is that the shutter time can be increased almost indefinitely because the camera and the subject will not move. (There is a mirror lock-up on reflex cameras so the motion of the mirror does not make the camera vibrate during the exposure.) If the shutter time is increased or made slower, the diaphragm of the lens can be closed down to achieve maximum depth of field. As described in Chapter One reciprocity failure must also be taken into account.

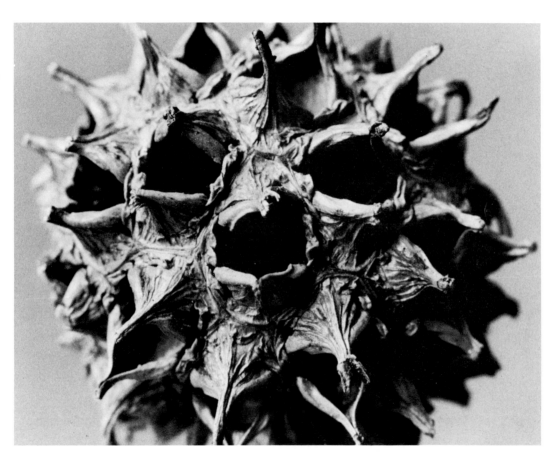

A tree seed: Crosslighting was used to bring out the texture.

COMMUNICATION LIBRARY, P.C.L.
13-22, RIDING HOUSE ST., W1P 7

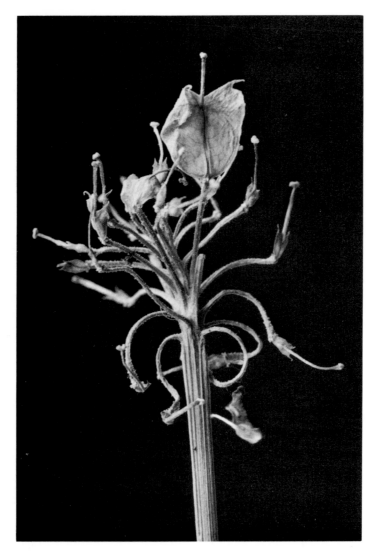

A dried weed.

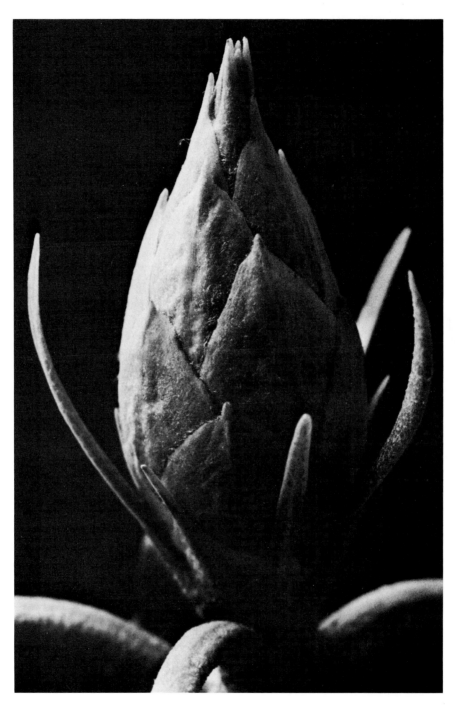

Rhododendron bud under skylight illumination.

Three-Dimensional Moving Subjects

Living subjects are by far the most difficult things to photograph in photomacrography. Not only do you have the old onus of depth of field, exposure, focusing, and camera and subject vibrations, along with the old challenge of composition and lighting, but you have the additional worry of subject movement.

Patience. Patience is the key word. Wait for a quiet afternoon when you are well rested and the subject is well rested or too exhausted to move. If black-and-white film is being used you can combine daylight with artificial light. (This will produce unnatural effects on color film because many artificial lights have different color qualities from sunlight.) Create reflectors to bounce the light back onto the subject. The subject may move out of focus at any time, but the combined effects of these lights should enable you to stop down the lens and get a deep field of sharp focus. The lighting also allows you to use a reasonably high shutter speed to reduce the chance of movement during exposure.

If you are using photoflood lights be careful that the subject is not broiled. At close range these lights generate great quantities of heat. However, a less frustrating method of taking a photomacrograph of a moving subject is with instantaneous light. The short duration of the light stops subject movement, even when the shutter speed cannot.

In combining non-instantaneous light with instantaneous light, the aperture setting should be based on the light from the flash. Guide numbers are calculated by trial and error tests because they vary with the equipment. The shutter speed should be based on the other light and the aperture already selected by the flash. However, the shutter speed must never be faster than the speed needed to synchronize the flash to the shutter. If the subject moves after the instantaneous light goes off but before the shutter closes, you will have strange ghost images recorded on the film, which may be interesting.

If your subject is a live animal, be prepared for it to walk out of the picture area at any time. Unless blur is the objective do not try to follow this action with the camera. The animal will probably walk too

fast and you will quickly become visually lost when there is no subject in the viewfinder. When the animal starts to pack up and leave, take your eye away from the viewfinder and gently but firmly guide it back to the appropriate spot. I have performed this action up to a dozen times before the determined creature would remain still long enough to make an exposure. If you can devise some way to confine it without blocking the light (perhaps in a glass cage), so much the better and more success to you. The best I could come up with was to raise the animal on a small platform. Usually this succeeded in temporarily detaining it, until it either fell or jumped off the platform. At least it paused long enough for a few pictures.

Another method of photographing the more hardy animals is to get all the equipment ready, put the animal down in a spot already focused on, and physically hold it while the picture is taken. It requires a sort of yoga to bend around and look through the viewfinder while you are holding the subject, but it is possible since the camera is close to the subject for the magnification. If fingers show up in the photograph they may serve as an informal standard of measurement so the viewer can imagine the size of the animal.

For photomacrographs of part of a person, the lighting should be as concentrated and strong as described above. To reduce the risk of movement the person should be comfortable and whatever you are photographing should be resting on something stable to avoid possible movement. If the subject is an ear, ask the person to lie down with his ear facing the camera. If the object of your photographic desires is a hand, place the person in a relaxed position with the hand resting comfortably on something.

Remember that skin is usually either lighter or darker than neutral gray and reflected light readings will have to be changed to compensate for the skin tones of your model.

Moving subjects can best be photographed with a reflex camera because the photographer must be continually refocusing. With view cameras too much time is consumed putting the film into and taking the film slide out of the camera.

Usually, to obtain maximum image brightness for focusing and arranging the subject, the largest opening of the lens is used. Then before the picture is taken, the lens is stopped down to the calculated aperture. However, if the subject is very active, you may want to view with the lens stopped down so you can take the picture the instant you see it.

BACKGROUNDS

If your subject does not fill the viewfinder, background will be in the picture. A background can enhance or destroy a photograph and therefore should not be ignored.

Indoors it is easy to create a background. Sometimes plain white paper is best and can serve as a reflector to bounce light around the subject. Choose a background judiciously. It should have uniform tones and textures within itself and, perhaps, different tones and textures from the subject so it does not steal the limelight. A blurry, confused mess behind your subject will be distracting and the results will be disappointing. The confusion is increased when the edges of your subject go out of focus and blend in with the out-of-focus background.

If you embark on treks into the world with your macro equipment, it may be a good idea to take along white, black, or colored cards, which you can prop up behind the subject to use as backgrounds. White cards can be used to reflect light into the darkened side of the subject. Change the angle of the card around while you are looking in the viewfinder to see when the maximum amount of light is being bounced at the subject. If you prefer natural backgrounds, there is always the possibility of changing your perspective by moving the camera up or down to simplify the background behind the subject.

Another problem that may be encountered out of doors is wind. When a gust of wind moves the beautiful object you were going to take a picture of just before you release the shutter, you must have patience and try again. It is possible to shield the subject by putting the background cards or something equally firm between it and the wind.

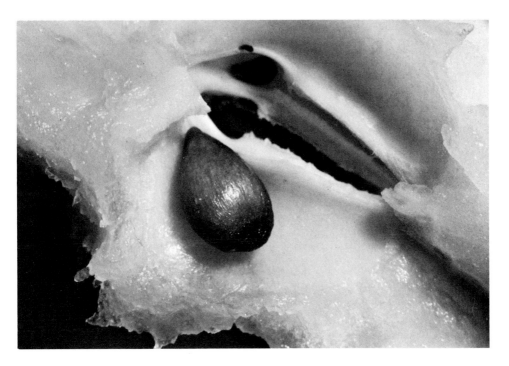

Above and on pages 71 and 72: apple cores.

CONTINUITY IN SUBJECT MATTER

After you have been immersed in photomacrography for a while and have individual pictures to show for it, you might like to try to make a series of pictures that are connected with one another in some way. Only a great picture can be as informative and interesting as a series of good pictures.

The most important element in a picture story is continuity. Below are five methods that can be used to achieve continuity.

First, photographs can be arranged in chronological order or how-to-do-it order. The growth of a seed or the steps involved in fixing part of a radio are examples of how photomacrographs can be employed in this area.

Second, it is possible to link pictures by showing the same object in different ways or by showing many small parts of the same large object. Examples of this method are photo essays, which can be on anything from the innards of a clock to rolling a cigarette.

Third, pictures have continuity if they illustrate a story. This requires that there be a beginning, a middle, and an end to a plot that the photographer has either found or imagined himself. Pick a story that lends itself to photographic images. For instance, you could illustrate the effort and diligence of ants in building their home, only to have it destroyed in an instant when somebody steps on it.

Fourth, you can show similarities between two or more items or contrast two or more things by presenting them visually. This is a common technique in photography with topics like age compared with youth, wealth compared with poverty, and so on. In photomacrography these pictures are usually more abstract than they are in photography because a small area must be made to symbolize something much greater.

Finally, the way the photographs are presented or laid out can make them sequential. If the photographs make their point and are presented with simplicity, the idea will reach the viewer much more quickly, pleasantly, and favorably than if too much is put into too small an area. If you arrange your pictures in the order they were taken, previously unrelated pictures will be tied together to show your progress in photomacrography.

Except for the last method, continuity can be successful if the photographer limits his subject, strives for impact in the individual pictures and in the topic as a whole, and reaches and maintains good photographic quality in every picture. Stick to one style in each group: do not make half the pictures in high contrast and the other half with normal tones, or some in color and some in black-and-white. A series should be unified in form as well as content.

You will probably find that joining pictures together is a good exercise that forces you to consider the subject in more than one way and may even help to raise the standards of individual pictures.

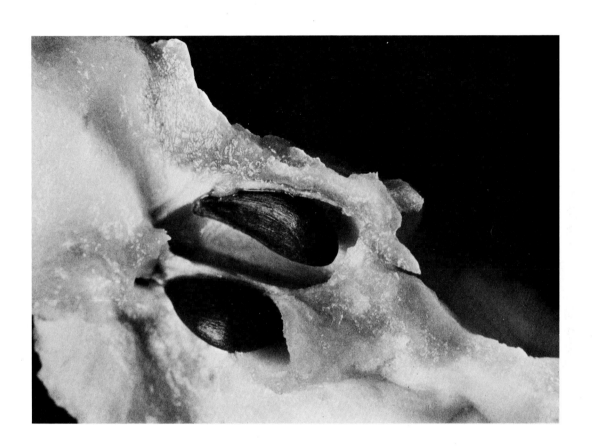

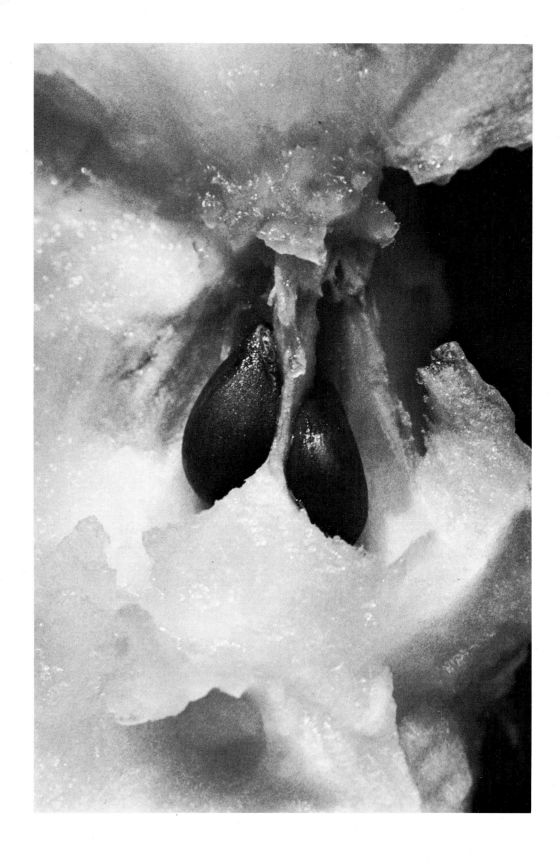

3

Uses of Photomacrography

Besides being an eye-opening hobby, photomacrography can be used to almost the same extent as general photography. As yet, however, the power of the macro image has been allowed to lie dormant; there are still many applications for it which are virtually untouched, awaiting your lens and skill.

EDUCATION

Very few things are more important than education, and a basic requirement of fruitful education is that it be comprehensible and interesting. Photographs are an excellent tool for showing something that is difficult or impossible to express in writing. Photographs can be used to augment or exemplify a text to make it clearer and more interesting. If there is a limited number of original subjects, photographs can make a field visually available to a number of students and in that way present them with things they otherwise would not have seen.

To appreciate the marvel of the growth of a plant, for example, one should really see it in life. Pictures can often serve as a substitute for the real thing and do the job much better than words. In at least one way photographs have an advantage over real life in demonstrating growth: photographs make the rate and progress of growth easy to compare from one day or week or month or year to the next. In life the change is so gradual that it can be frustrating for an impatient young student to observe.

Photomacrography can also be used in education to show parts of objects, living or non-living. In technical fields, for instance, it can illustrate parts of a watch,

engine, telephone, or computer, and show how they should be joined to other parts. Objects that are too small for the unaided eye to perceive will display their full details and intricacies under the macro lens. Would you have ever guessed or would you have been willing to believe that a fly's leg has tiny hairs on it before you actually saw a magnified picture of a fly's leg?

Photomacrography and education is an expansive combination, capable of contributing to many areas of study. It is possible with this medium to demonstrate the correct way to hold a pencil or to show bits of glass in a moon pebble; the limits are described only by your imagination. Education is entangled in all of the next sections on the uses of photomacrography. It would be impossible and foolish to try to disengage the two.

Science

The inside and outside of the human body must be recognized in their healthy and unhealthy states by those in the medical profession. There is no question that photographs can play an important role here, for the practicing physician and for the medical student. Macro pictures of retinas, eardrums, hearts, blood clots,

Five-day-old leaf with fungus.

74

lesions, embryos, and hang nails, to name a few, make it possible for these men of medicine to become familiar with the numerous functions and malfunctions of the human body.

Photomacrography is widely used in entomology, the branch of zoology concerning insects. The small size of the insects under study make them ideally suited to magnification.

The other branches of scientific exploration should not be ignored from a photomacrographic point of view. Animals besides insects can be meticulously examined with the aid of a macro photograph. This could include your house pet, if it is quiescent when, where, and for the length of time you want it to be. Although somewhat overused by color film manufacturers as examples of high-quality color work, flowers and plants can also make informative pictures. A profound statement that may help a photographer about to take a picture of a stale subject is: discovery is seeing what others have seen and thinking what no one has thought.

Chemicals and chemical reactions, as mentioned above, can be photogenic and profitable for chemists. The same holds true for other areas of scientific study; it is easy to imagine how photomacrography can be used, for example, in geology and mineralogy.

Philately

Philately, like entomology, lends itself well to macro work. Granted, taking pictures of stamps is not as awe-inspiring as photographing bubbling chemicals or white corpuscles, but if stamps are your bag or even of mild interest to you, it may be worthwhile to learn how to take photomacrographs of them to show friends or customers.

The stamp may be changed from one shot to the next, but the camera settings need not be changed if the lighting remains the same. Therefore, if you take pains to erect a simple, easy-to-duplicate, light and camera setup, you can be fairly certain of the correct aperture and shutter speed settings. Before you can reach this plateau, however, you will have to make test exposures in which you carefully record the shutter speed and aperture used on each frame of the film. On these test

negatives, bracket so that every frame has a different shutter speed or aperture. When you see the developed results you should be able to pick a density you like and find its corresponding exposure in your carefully kept records. Thus, you will have the perfect exposure for that lighting setup, with the camera in that position, with that magnification, and that film. If any of these factors are different the next time you shoot, naturally the exposure will have to be altered to compensate for the change.

In lighting your stamps, you may want to show the designs and words and perhaps colors on the stamp rather than its texture. For that reason the light source should be placed above the stamp, shining down on it. If the light is made to shine across the stamp, the texture or bumps and bends will be visible because of the formation of shadows.

Remember that color film may require a filter if it was not made for the type of light you are using. Even if you are using black-and-white film, you may want to experiment with filters (the X1 filter, for example) so that the tones in the stamps are more accurately recorded. Contrast filters can be used to lighten or darken different colors so that they are not rendered as identical tones. For example, the No. 25(A) filter is red and will transmit red colors and absorb green colors, so red is rendered lighter and green darker in the print, separating what could otherwise be similar tones.

COMMERCE AND INDUSTRY

Parts of products, parts of the tools and machinery that go into making the products, the stresses, strains, and breaks involved in the production processes, the uses of machinery, all are apt subjects for photomacrography, which can be valuable in communicating industrial information.

Through the use of photomacrography, Madison Avenue has been able to expose the public to a good close look at spark plugs, colorful tiny time capsules, green crystals in a detergent, the edges of a razor blade, as well as other parts of products in an unabashed attempt to wrest us away from competitors.

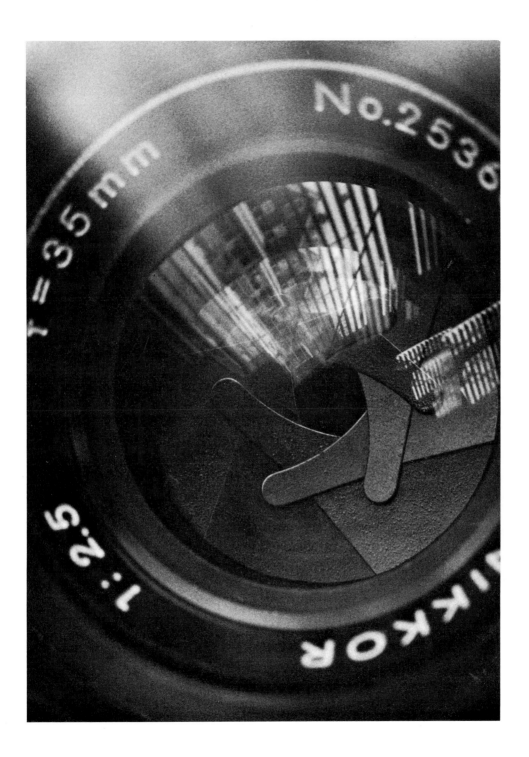

The reflections in this camera lens are from Venetian blinds and houses outside the window.

PHOTO ESSAYS

The methods suggested in the last chapter for achieving continuity are also uses of photomacrography for communication.

To create a photo essay using the macro image takes a great deal of thought. You must consider minute portions of the subject that will be recognized in the photograph and understood as relevant, or, if unrecognizable, should lend themselves to concise explanation so that they will suddenly become recognizable. Ordinarily, if a picture has to be explained, this is an indication of some sort of failing on the part of the photographer. The specialized field of photomacrography, however, is an exception to that rule because, for one thing, most people are seeing the object in a new way and it is therefore temporarily foreign to them; second, the very fact that a common object is unrecognizable and at the same time interesting and possibly pleasing to look at is what makes photomacrography pulsate. If a photo essay assignment were to be of a wrestling match, photomacrographs of straining fingers, beads of sweat, ear protectors, and a forehead creased with pain could all be part of the essay. Any photo essay topic, in fact, can be given new depth with judicious use of photomacrography.

A macro breakfast is served on pages 79–85. Right: bits of orange in a glass after the juice has been consumed.

Above: toast. Below: a waffle.
Right: bread.

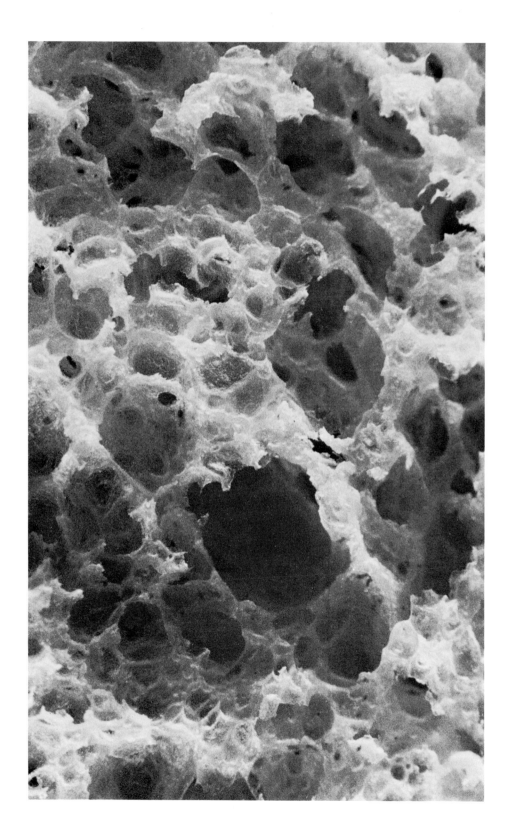

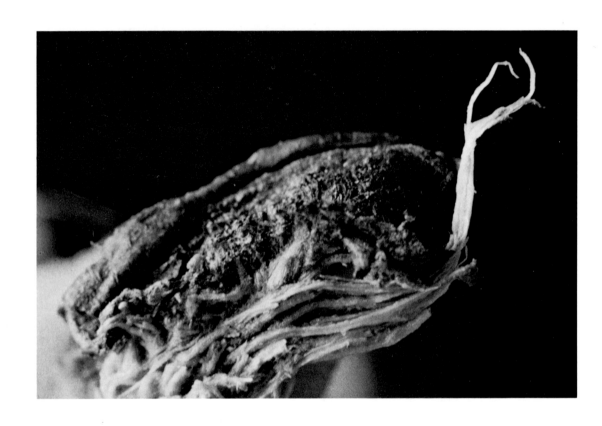

Above: the end of a banana. Right: a slice of overripe banana.

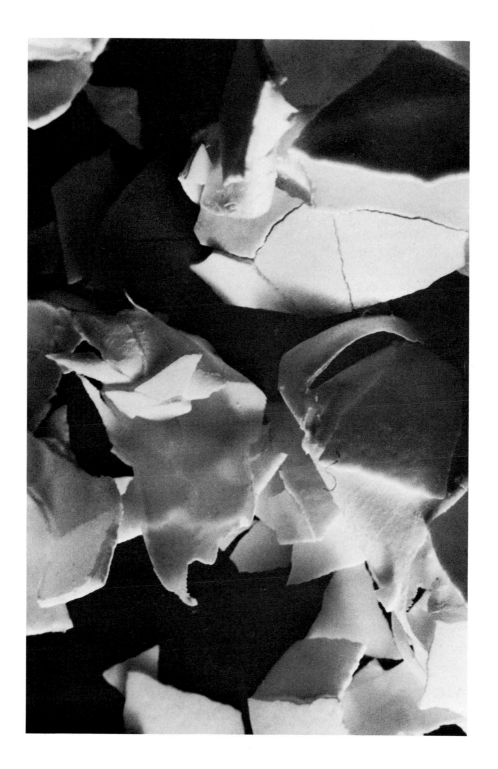

Left: dried egg white. Above: an egg shell.

THE PHOTOMACROGRAPH AS AN ART FORM

In every photomacrograph you take you should be unconsciously aware of composition. The most important rule of composition is that there are no rules of composition that are so inflexible that they can never be broken. Composition is as personal to the photographer as are his photographs and cannot be a prescribed arrangement. This does not mean that good composition will not come more easily with practice or that there is no need to be sensitive to the compositional work of other artists. If a picture has nothing to say, if the photographer has nothing to express, composition is for naught. Composition is analogous to form; content, to substance.

Right: red cabbage.

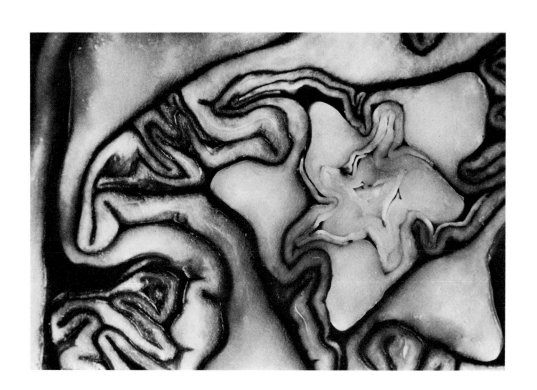

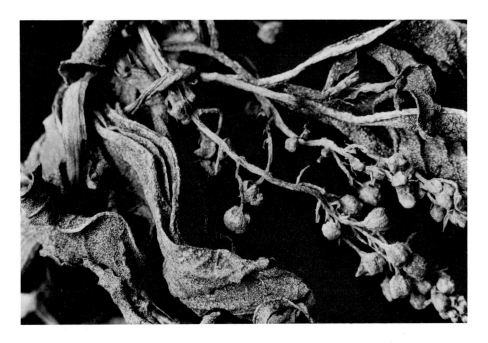

Above and right: different parts of a weed lit with direct sunlight.

Photomacrographers have a tremendous amount of control over the quantity of the subject they include (by varying the magnification), what portion of the subject they include (since a slight movement of the camera or subject changes the part of the subject under observation considerably), and the colors or tones of the subject (by the use of filters, films, developers, lighting, and printing). With these methods at our disposal we have a lot of leeway as to the design and balance of our pictures. We should not abuse this leeway by plopping down the object and taking the picture of the first thing focused on. Instead, we should turn, push, pull, lift, and lower it or the camera very slowly until we find that our eyeball is repeatedly being caught by the same section of the subject. Then we are sure that we have found "our spot" and after it is lit to the best advantage, shooting can commence. It is frustrating to take pictures of one area only to find that there is another area a few inches away that is a great improvement over the first.

In general photography emphasis can also be controlled by highlighting the important area and by using scale variations, both of which are generally difficult to use in photomacrography due to the small size of the area under observation.

Besides arrangement, emphasis can be controlled by manipulation of the sharpness. Focus accurately on what you want the viewer to see. If that is all you want him to see clearly, open up the lens to a wide aperture in order to create shallower depth of field. If you would like as much as possible of the subject in focus, close down to a smaller aperture.

The average photomacrograph is abstract. This enables the photomacrographer to take a picture of a form which is concrete when viewed in its entirety, but unrecognizable and therefore abstract when small parts of it are magnified. The artist will find unlimited subject matter at his disposal. But the identification mystery, which engulfs so many macro images, means that the viewer will be forced to look at the composition. The subject matter will not block his view, and he will be able to judge the composition from an unusually objective standpoint.

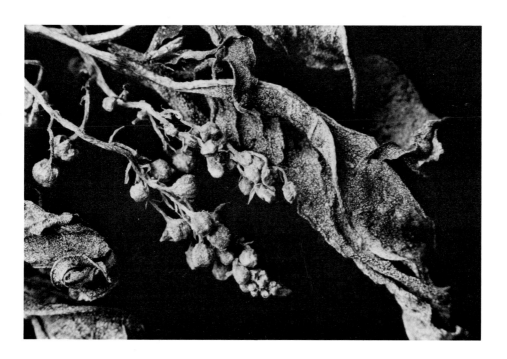

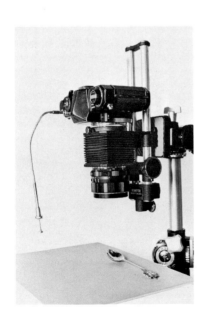

Above: reflection in an egg spoon. The camera setup at left was used to take this picture.

90

4

Photomacrography with Other Techniques

If you do not approve of tampering with the image, the negative, or the print, then this chapter is not for you. The following guidelines are not at all meant to be critical of this purist style of photography, but many photomacrographers today are interested in special effects. The majority of these effects concern black-and-white film and require you to have a knowledge of and to do your own developing and printing. These techniques can be used with general photography as well as photomacrography.

It is difficult to visualize beforehand the effect a special technique will have on a specific image. With experience, though, you will become increasingly familiar with the results of the various techniques and have a better idea of which one would be most advantageous to the subject at hand.

HIGH CONTRAST

Contrast is the visual difference between tones in a print. Without contrast a print would be imageless because it is only the whites, blacks, and shades of gray that portray the image.

High contrast is the elimination of many middle gray tones, leaving primarily black and white. This effect is usually very graphic and is quite easy to achieve.

Five points where you can change and control the contrast of an image are: (1) choice of subject matter; (2) lighting; (3) type of film and exposure; (4) development of the film; and (5) choice of printing paper.

1. *Subject matter.* If you wish to eliminate the subtle gray tones in your photograph it is, of course, best to start out with a subject that does not have many middle tones in it.

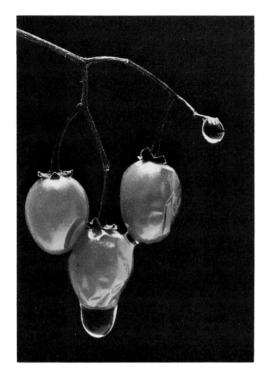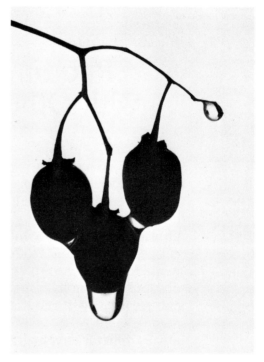

Left: Light was reflected directly onto a bunch of wet berries. Right: Light was directed onto a white card behind the berries to produce a silhouette.

2. *Lighting.* Hard crosslighting creates the most contrast. A *hard* light is one that is strong and not diffused, but rather aimed directly at the subject. *Crosslighting* means that the light source forms a 45° to 90° angle to the camera, the subject being the vertex of the angle. The light is skimming across the surface of the subject, creating brilliant highlights and deep shadows. As an alternative, probably the simplest way to get high contrast is through silhouettes. In this case the light should not be thrown on the subject, but rather on the white background behind it. The subject then appears as a black shape.

3. *Film.* As mentioned in the first chapter, one of the several inherent characteristics of film is its contrasti-

ness, and if you want high-contrast results, use a high-contrast film. Graphic art film is extremely contrasty, Panatomic-X is less so but more contrasty than either Plus-X or Tri-X. The contrastiness of a film is usually alluded to on the data sheet included with the film. Generally, the slower the speed of the film, the greater the contrast.

4. *Developing*. The way you develop the film will also influence the degree of contrast it will have. Active film developers that require short development time will generally produce more contrast than slower film developers. Everything else being equal, the longer the film is developed beyond its normal development time, the more contrast it will have. Therefore, for high contrast, pick a fast-acting developer with a relatively short recommended development time, underexpose the film, and then develop it beyond the normal time with increased agitation. The film is underexposed to compensate for the increased density that results from over-development. Developer, development time, and agitation can only increase the contrast of a film to a certain maximum, however, depending on the film type and the image.

If Panatomic-X film is normally developed for seven minutes at 68° F., for high contrast it can be slightly underexposed and developed for eight or nine minutes. The best underexposure–overdevelopment balance for the high-contrast effects you want can be determined by a few trials.

5. *Printing*. The type of paper or polycontrast filter you use in printing will determine the contrastiness of the image. Photographic papers are numbered according to their contrastiness; paper grade No. 1 will give flat results on a normal negative, whereas No. 6 will give contrasty results on the same negative. A *normal negative* is one that will print best on a No. 2 paper. If a very flat negative is printed on No. 6 paper, it may then appear to have average tonal gradations because the contrast of the paper will have compensated for the lack of contrast in the negative.

The type of surface of the paper will also change its apparent contrast. Glossy grade No. 4 paper has more apparent contrast than matte grade No. 4 paper.

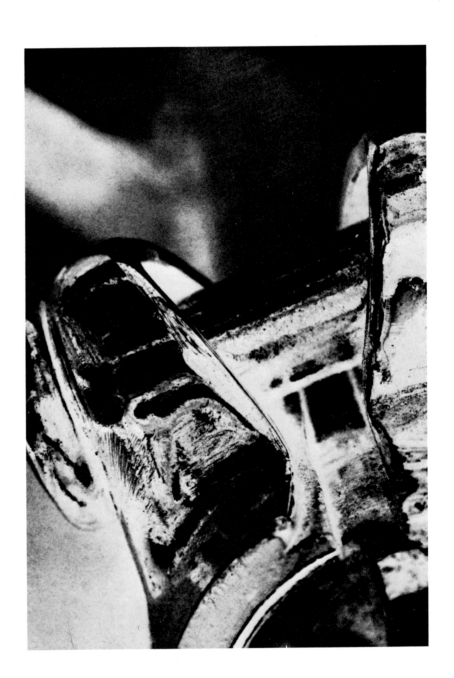

THE NEGATIVE PRINT

Very simply, a negative rather than a positive image on photographic paper is a negative print. To make a negative print you must first make a normal print or, perhaps, one that is slightly flatter than you like because this process adds contrast. After this print has been developed, stopped, fixed, washed, and dried, place it on top of an unexposed piece of photographic paper, emulsion to emulsion. This means the shiny side of the unexposed paper is next to the image side of the print. Then place a piece of glass over the two papers so that there is contact between the emulsions, and put them under the enlarger light or any other strong white light. When the imageless paper, which is on the bottom, is developed, it will have a negative image because more light will pass through the lighter areas on the normal print and reach the unexposed emulsion directly beneath it than will pass through the darker areas of the print. Since the areas that receive more light become darker, what is white on the original print will become dark on the second print, making it negative. It is possible to make negative prints if both papers are wet, but there is a problem if air bubbles get trapped between the papers; air bubbles make the density of the negative print uneven. It is also possible to make negative prints if the emulsions of the papers are not facing each other, but here again the quality of the negative image suffers.

If you repeat the above procedure of sandwiching exposed and unexposed papers together but use a negative print, rather than a normal print, you will once again have a positive image. As this process continues (positive to negative images and vice versa) the quality of the image deteriorates or perhaps becomes more inter-

Negative print of part of the handle bars of a bicycle.

95

esting because of the texture of the paper, which becomes part of the print.

The length of the exposure varies with the thickness of the exposed paper that is on top. Single-weight and especially light-weight paper reduce the length of exposure. The density of the image, the quantity of light, and the distance from the light to the paper also affect the exposure.

To avoid wasting paper when experimenting to find the correct exposure for your set of conditions, it is possible to use test strips of paper, or expose a single sheet one section at a time. The exposure you decide on should be satisfactory for the whole print, but if is not, burning and dodging can be done on negative prints by lightly marking on the topmost surface which areas need more or less light. Retouching is also very easily accomplished. If an area in the positive print is too light, shade in the back of the print with a pencil in the corresponding area; this will make that area denser, allowing less light to pass through and resulting in a less dense negative print in that area. This can also be done on the negative print when you are making a paper positive from a negative print.

Finally, the use of graded papers can adjust the contrast of negative prints. Polycontrast filters do not work as well because they require unpleasantly long exposures.

BAS RELIEF

In printing, bas relief is an effect that gives the illusion of a raised, or three-dimensional, print. To create this effect you first need two identical images, one a film positive and the other the usual film negative.

To duplicate a negative, in complete darkness sandwich the negative you want to duplicate with an unexposed piece of film between glass, the exposed negative on top. Then turn on a weak safelight for a short period of time (film is much more sensitive than paper), and develop the new image, once again in complete darkness. You will probably have to experiment to determine the correct length of exposure, but after you have the formula you will never have to experiment again unless you change the factors. Remember to

record the length of exposure, the type of light source, the type of film that is used to record the positive image, the film-to-light distance, and the type and length of development. For bas relief work 4" × 5" or 2¼ square negatives are easier to work with than 35mm. If you have a 35mm negative, you can enlarge it onto a very slow, larger-format film such as line copy film.

Next, take the two film images, one negative, the other positive, place them on top of each other slightly out of register, and print them just as if they were one negative. The more you move the images out of exact alignment, the more bas relief effect you will achieve in the print. You can vary the effect by moving the positive and negative images horizontally, vertically, or diagonally away from each other.

Different effects will also result if the density of the positive image is changed. Density should usually be thin, but you can experiment with thicker densities for strange effects.

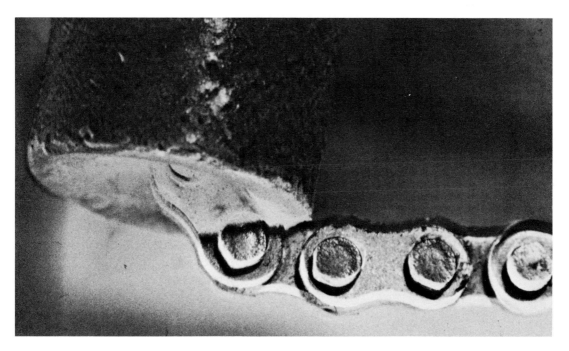

Bicycle gear chain in bas relief: The two negatives were moved away from each other diagonally.

MULTIPLE EXPOSURES

Any time there is more than one image on a negative, we call it a *multiple exposure*. Although this is often done accidentally, it is also a good artistic device. It can be done deliberately by one of three methods: several flash exposures, in which case the shutter is left open and the subject moves after each flash of light; turning non-instantaneous light sources on and off in an otherwise dark room; or releasing the shutter two or more times.

In the first two methods, if a black background is used and the images from the different exposures do not overlap, then the camera settings will be the same as they would be for one exposure. This is because the black background prevents additional light from getting to the film. The film is therefore unexposed except for the area that the subject occupies.

The third method, of releasing the shutter more than once, can be very controlled or very haphazard. It is possible to take pains to remember the position of each image you take so that consecutive images add to the total design of the photograph; you can also try luck by running one roll of film through the camera more than once, making no attempt to remember what the previous exposures were about. If 35mm or 2¼″ film is being used and it is desirable to have each consecutive negative fall exactly on top of the first, rather than falling on the spaces between the frames, then on the first run mark the film or the paper backing to correspond exactly with a specific, adjacent point in the camera. When the film is put through again, be sure to realign these points.

If you are reexposing the whole frame and the subjects from the different exposures are overlapping, then you must decrease the exposure, usually by one stop, or half the normal exposure. Decrease it more than one stop if you are putting more than two exposures on one frame.

To make the combination print at right, dried rubber cement was photographed and the negative printed; then a negative of an eye was printed onto the same paper.

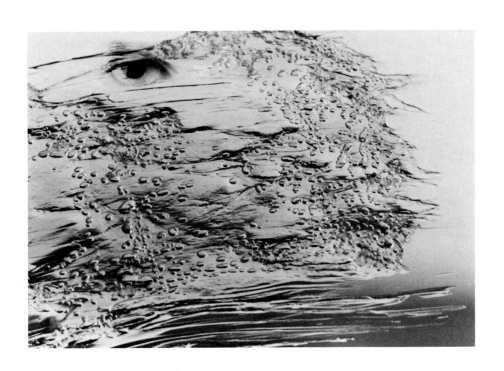

Photography Film
and Communication Studies Library
The Polytechnic of Central London
309 Regent Street W1R 8AL

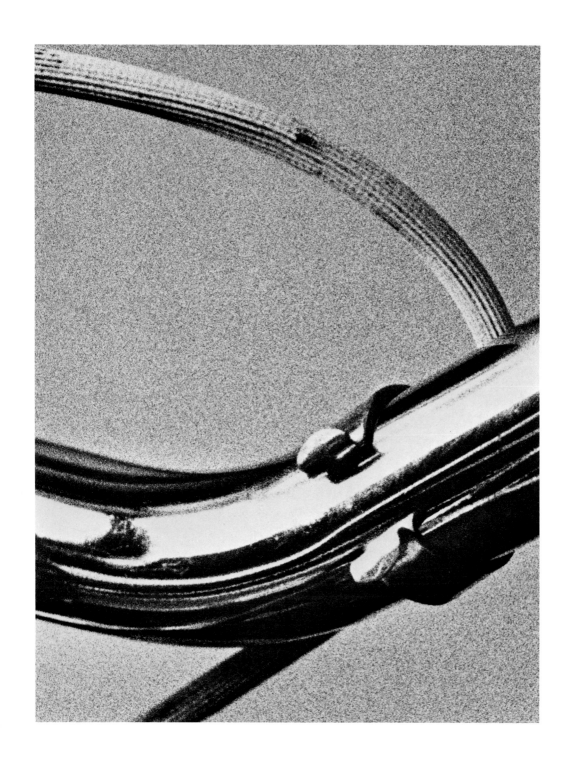

Left: Recording film developed in DK-50 produced the grainy effect in this photograph of a brake cord and handle bars on a bicycle. The background was a neutral gray card.

COMBINATION PRINTING

Combination printing is the use of two or more negatives to make one print. It can be accomplished by either exposing the paper to two or more negatives simultaneously (sandwiching the negatives in the enlarger, emulsion to emulsion) or by using one negative at a time to expose the same piece of photographic paper. It is usually difficult to get even densities from the different negatives, and it is also a challenge to make the images fall exactly where you want them, especially when you are changing negatives.

In simultaneous printing, the print will be lighter where the images overlap due to the adding of densities of the negatives. On the other hand, in successive printing, the print will be darker where the images overlap, due to the adding of densities on the paper. To make the boundaries between the images less abrupt, you may be intrigued with Farmer's Reducer, a chemical mixture that decreases density in a negative. Ferricyanide has the same effect on prints if you do not want to risk fooling around with your negatives.

GRAIN

Grain is another one of the several inherent characteristics of film. The image on a negative is made of many tiny clumps of black metallic silver. When the negative is enlarged, these particles are enlarged along with the spaces between them. When it is possible to see these tiny clumps individually because of the spaces separating them, the print is considered *grainy*. The

more space between the clumps, the more grainy the print. Grain always shows up more in the middle tones of the print than in the light or dark areas. The denser the overall negative, the more grain it will have, but dense negatives are difficult to print and lose much quality. Some grainy prints are very pleasing; there are several methods that can be used in combination or individually to get grain.

First, the type of film used. In general, the faster the speed of the film, the grainier it is. This is because faster film has larger halide crystals in the emulsion and consequently is more sensitive to light and grainier than slower film. The grain size of the film is directly linked to the contrast of the film. The larger the grains, the less contrasty the image. The resolving power of the film is also related to its grain size. The larger the grains, the less the resolving power.

Second, enlargement increases graininess. If you enlarge a small part of the negative, or if you enlarge the entire negative a great deal, the metallic silver particles and the spaces between them will become increasingly visible.

Third, the way the film is developed influences the amount of grain it will have. Below are some film–developer combinations that will help you get graininess:

Film	ASA	Developer	Dilution	Temperature	Time
Tri-X	1600	Rodinal	1:50	80° F.	18 min.
Tri-X	800	Dektol	1:1	68° F.	3 min.
Kodak 2475 Recording*	1000	DK–50	undiluted	68° F.	6–9 min., depending on subject contrast

*Kodak 2475 Recording film curls upon drying. One way to overcome this curling is to wind the film onto the reel emulsion side out, after processing has been completed, and let it dry on the reel.

Fourth and finally, the type of light in your enlarger and the type of paper you use will make a difference in the grain of the print. Condensor-type enlarger illumination makes prints that appear grainier than the softer, diffused illumination. Gray tones from the same negative will appear grainier on high-contrast paper than on lower-contrast paper.

SABATTIER EFFECT

The partial reversal of an image when it is exposed to unsafe light for a short time during development is called the *Sabattier effect*. What happens is that the areas of the emulsion that were dense before the exposure to light may not become much denser; areas that were thin increase in density considerably when development is continued after the exposure to light. The lack of one reaction and the increase in the other results in a partial reversal of the image.

To attain a Sabattier effect on film, the following method may be used. Part of the way through development the film is taken out of the developer and off the reel, briefly exposed to a weak white light, and development is continued with no agitation. When the film is held up to the light it should be on a flat, smooth surface, parallel to the light. After the film has been in the developer for the second time, it should be stopped, fixed, and washed normally.

Quantitative data about the length of the second exposure are difficult to specify because there are many variables involved — the strength of the light, the light-to-film distance, the type of film, and so on. Suffice it to say that the second exposure will usually be short — a few seconds perhaps. If the film is exposed too soon during its development, the middle tones will be too dense; if the light is turned on too late, the film will hardly show the Sabattier effect at all. Here again, some experimentation is required. The Sabattier effect seems to have the most impact when the image has large areas of dark tones and simple shapes.

To avoid permanently ruining negatives, it is possible to enlarge them on to a very slow, large-format film, Line Copy 4" × 5" film, for example. This process will make a positive image; if it is repeated a negative image will be produced. These copies of the negative can be used for the Sabattier effect, thus leaving the original negative unscathed.

To produce the Sabattier effect on paper, the following method may be used. Expose the paper just as if you were making a normal print, but after the print has been developed, take it out of the developer. Give it

about three brief flashes — one or two seconds altogether may be enough — to white light and leave it where it is until it appears almost completely black under safe-light conditions. After it has been stopped and fixed normally, and the white lights can be safely turned on, you should see to your delight and amazement, rather than a black piece of paper, very delicate, etched lines around the edges of the image. To lighten the print and these lines, soak it briefly in an extremely weak solution of potassium ferricyanide and then put it back into the hypo and wash. Repeat the ferricyanide-hypo treatment until the print is as light as you like it. (Caution: ferri-cyanide ruins hypo. After this treatment, mix fresh hypo.)

The etched lines mentioned above appear between areas of greatly differing densities on prints and nega-tives that have been reexposed to create the Sabattier effect. This is because the chemicals in the dense areas of the emulsion are exhausted before the second expo-sure and retard development around their borders, resulting in a thin line of low density between dark and formerly light areas after the second exposure. If these etched lines are on the negative, they appear as dark lines on the print and vice versa.

In the case of both film and print Sabattier effects, the length of the initial exposure and development as well as the length of the second exposure and develop-ment can be varied for different effects.

TONING PRINTS

Toners change the grays and blacks of a print to a color. They are available in some photo stores in a variety of colors: sepia, selenium, gold, lead, green, yellow, orange, red, and others.

Fast-working toners usually employ a bleaching bath. The print is soaked in the bleach until the image has disappeared or at least is considerably weakened. Then the paper is soaked in the toner solution until it has slightly less than the desired density, because the toning action will continue after the print has been removed from the toner.

Slow toners are direct and do not employ a bleaching bath; the print is placed in the toner for 10 or 20 minutes.

The kind of photographic paper used will affect the quality of the toning action. If you are unhappy with the results from one paper, another type may be more satisfactory. There are some papers on the market that render tones other than black, white, and gray. Most paper manufacturers offer paper with an inherent tone. These papers have color upon development and do not require a toning process.

COLORING BLACK-AND-WHITE PHOTOGRAPHS

Rather than changing the whole print to one color, as in toning, black-and-white photographs can be colored in local areas and in a variety of colors. The entire print can be colored in this way, or just a small section of it, leaving the rest in black-and-white.

One medium for this technique is transparent colors. They can be bought either in solution or dry and are applied onto appropriate areas of the print with a fine brush. The most absorbent print surface for this is semi-matte. The paper should first be soaked in warm water, then placed on a hard surface and wiped of its excess moisture so that it is damp but not dripping. The color is applied one thin coat at a time; the lighter the area of the print, the stronger the color will appear due to its transparency. On the black areas of the print it will not show up at all. In general the colors should be well diluted and used in combination with other colors, not straight.

A less effective way to color prints is by using ordinary water colors. To prevent the water color solution from beading up on the print, you can mix it with a little bit of soap to break up the water tension. Water color may be frustrating to work with because it is difficult to apply evenly, and usually there is a hard rim around the edge of the area being colored.

Finally, retouching dyes and transparent oils are available in many camera stores for hand coloring prints.

Right: photogram of peacock feathers.

PHOTOGRAMS

Photograms do not involve a camera or film. They are made with photographic paper, light, and a subject. The subject is placed between the light source and the paper. The shadows from the subject are recorded on the paper as white areas; translucent parts of the subject become shades of gray. The subject can also be placed directly on the paper and held flat with glass. Photograms fall under the category of photomacrography because if the subject is placed near or on the paper a life-size image is recorded and is therefore a macro image.

The objects that can be used to make photograms are almost limitless. The type of light source, the angle and quantity of light, the grade of photographic paper, and the development of the paper are all variables that can be experimented with. It is even possible to add to the design of the image by staining the paper beforehand. Of course, the subjects can be moved or removed or replaced with other items during the exposure.

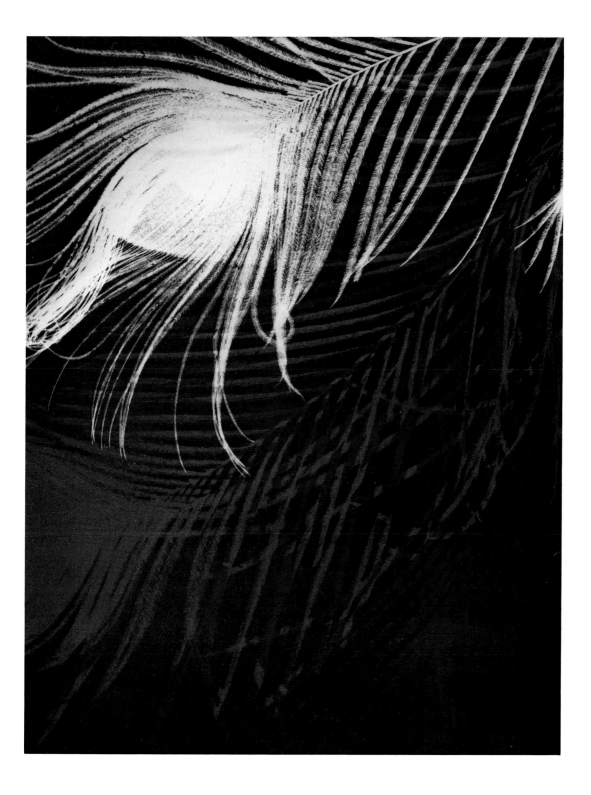

DIRECT ENLARGEMENTS

Direct enlargements, like photograms, do not require a camera or negative. The object is put directly into the negative carrier of the enlarger and printed onto the paper. Thus, the object is magnified. Obviously, the object must be able to fit into the negative carrier of the enlarger, a very limiting factor. The most interesting results may come from subjects that are partly transparent, such as etched glass, cellophane, and so on.

Above and right: direct enlargements of Photo-Flo bubbles.

108

Above and right: direct enlargements of D-72 crystals.

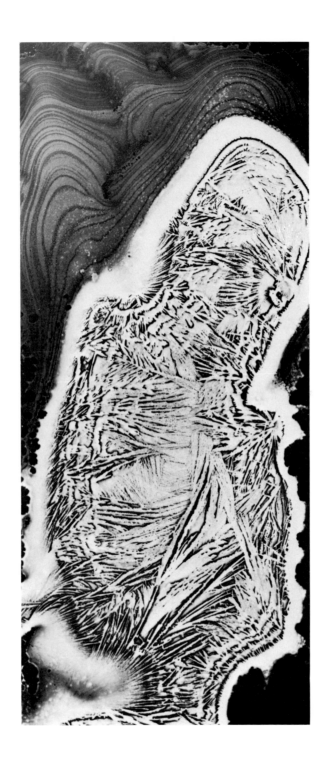

Glossary

Aperture. The hole in the lens diaphragm, which can be varied in diameter (by changing the f/stops) to allow more or less light to pass through the lens and reach the film; the diameter of the opening admitting light. The aperture controls the brightness of the image — the larger the opening, the brighter the image — and the depth of field — the smaller the opening, the greater the depth of field. As the f/stop numbers become smaller, the size of the opening in the diaphragm becomes larger, allowing more light to pass through the lens. For example, there is a larger hole when the camera is set at f/2.8 than when it is set at f/4.

ASA number. The American Standards Association's system of measurement for photographic film indicating its relative sensitivity to light under specific, controlled conditions. For a given camera setting (aperture and shutter speed) and a given amount of light, one type of film could be underexposed, one could be normally exposed, and a third could be overexposed. Therefore, every film type has its own speed, which is an important factor in calculating the correct exposure. If a film has an ASA number of 400, it is twice as sensitive to light as one rated at ASA 200 under the manufacturer's testing conditions. The ASA rating can be adjusted on the light meter to correspond to the film being used. The ASA number is usually determined by the manufacturer of the film. This number may be inaccurate if it is used under lighting conditions that are not similar to the manufacturer's testing conditions. For example, most film is tested in daylight. Many black-and-white films, however, are less sensitive to artificial light

than they are to daylight, due to differences in wavelengths. Under artificial lighting these films will be underexposed if the ASA number for daylight is used. The ASA rating is usually written on the film box, the film data sheet, and the film cassette. DIN is the German equivalent of ASA, but uses numerically lower values for comparison.

Bellows factor. A calculated correction in exposure when the lens is abnormally extended from the film plane of the camera. This correction is necessary because as a subject approaches a lens, the image it forms is increasingly farther behind it; and the greater the distance between the lens and the image, the weaker the image. Exposure meters outside the camera do not calculate for this decrease in intensity and the photographer must adjust for it. Most through-the-lens meters do measure this less intense light, making bellows factor exposure adjustment unnecessary.

$$\text{Bellows factor} = \frac{\text{Bellows extension}^2}{\text{Focal length of the lens}^2}$$

Be sure to use the same units of measurement for bellows extension and focal length. They should either be in millimeters or in inches.

Cropping. Eliminating unwanted areas of the subject by either careful placement of the camera or trimming the negative or print.

Density. A measurement of the degree of blackening of photographic emulsion after exposure to light and after development. The greater the amount of light that reaches an area of the emulsion, the denser it usually is upon development. Since the light areas of a subject reflect more light than the dark areas, the light areas of the subject are represented as dense areas on a negative. The dark areas of a subject are represented as thin areas in the negative. When a print is made from a negative, the dense areas of the negative restrict light and the thin areas transmit light, so once again the tones are reversed.

Depth of field. The nearest and farthest points that can be brought into acceptable focus on the film plane at the same time. In photomacrography, depth of field depends on the degree of magnification and the

aperture of the lens. The greater the magnification and the larger the aperture of the lens, the shallower the depth of field. In practical terms, if the depth of field is small and the subject is three-dimensional, only a small portion of the subject will be in focus.

Diffusion. When light strikes an opaque or translucent object and is scattered, it is said to be *diffused.* By bouncing light off an opaque diffuser or shining light through a translucent diffuser, the light is spread out and soft shadows are created.

Emulsion. A photographic emulsion is a light-sensitive coating of silver halide particles suspended in gelatin. It is coated on either an opaque base to make paper or on a transparent base to make film.

Light meters. Instruments for measuring the intensity of light and for translating these measurements into terms of aperture and shutter speed. There are two ways meters can measure light: (1) by incident readings, where the meter is pointed at the camera from the subject position, measuring the light that falls on the subject; and (2) by reflected readings, where the meter is pointed at the subject and measures the light that the subject reflects. Reflected meter readings are either spot or averaging. Spot meters read a small area of the subject; averaging meters read a much broader area of the subject and average the light from all areas. Most meters built into cameras make reflected light readings; some of them are spot meters.

F/stops. Numbers representing the opening in the diaphragm of the lens. Small numbers represent large openings and vice versa. See *Aperture.*

Focal length. The focal length of a lens is equal to the distance between the lens and the film plane when the lens is attached directly to the camera and focused on infinity. The focal length of a particular lens is usually written around the front element of the lens. For example, a lens with a focal length of 50mm will usually have "f = 50mm" written on it.

Fast film. Film with a relatively high ASA speed, that is, film relatively more sensitive to light than other film. For example, Tri-X film, with an ASA of 400, is faster than Plus-X film, which has an ASA of 125.

Guide number. A number used for calculating the correct

exposure for a particular flash unit or electronic flash. The guide number is based on the intensity of the instantaneous light, the speed of the film used, and the flash-to-subject distance. The guide number equals the aperture multiplied by the flash-to-subject distance, or G = A × D.

Latitude in exposure. The tolerances in exposure a film will allow and still yield acceptable results. Practically speaking, latitude should influence the amount of bracketing that is done. Bracketing should be more extensive when the exposure must be accurate, that is, when the film has narrow tolerance for incorrect exposures.

Negative. An image on film or paper in which the dark areas of the subject are represented by light areas on the emulsion and the light areas of the subject are represented by dark areas on the emulsion. In other words, the tones are reversed. See also *Positive.*

Open up. To allow more light to reach the film by making the aperture larger. A large aperture is represented by a small *f*/number. Therefore, to open up a lens could be, for example, changing the aperture from *f*/5.6 to *f*/4.

Positive. An image on film or paper in which the dark areas of the subject are represented by dark areas on the emulsion and the light areas on the subject are represented by light areas on the emulsion.

Shutter. The shutter on the camera controls the length of time light is allowed to reach the film.

Slow film. Film less sensitive to light than fast film and therefore having a lower ASA number. For example, Panatomic-X film, with an ASA of 32, is slower than Plus-X film, which is rated at ASA 125.

Stop down. To allow less light to reach the film by making the aperture smaller. For example, changing the aperture from *f*/8 to *f*/11 is stopping down. See also *Open up.*

Tonal range. The varying densities in a negative or print from white, to off-white, to all the shades of gray, to black; the interval from shadow to highlight.

Index

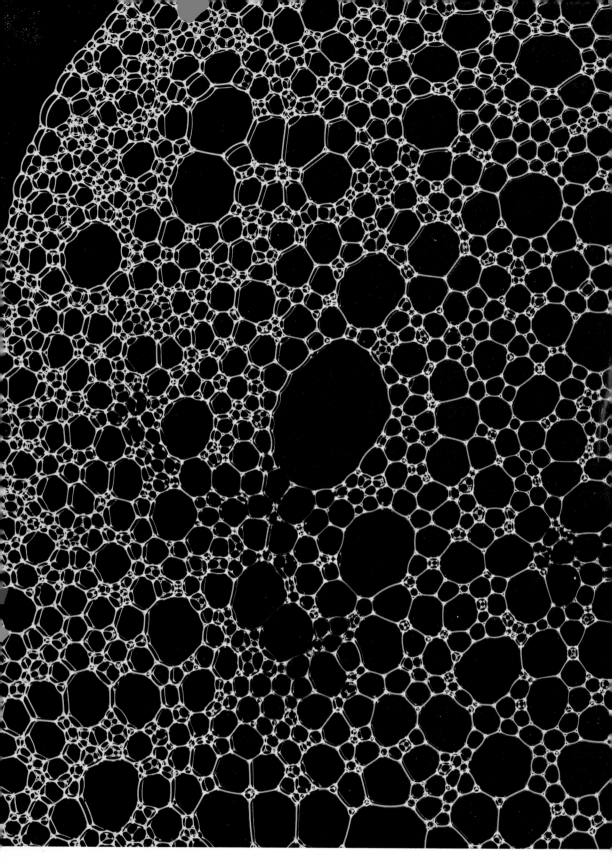

Direct enlargement of Photo-Flo bubbles.